NORTH MISSISSIPPI

MURDER & MAYHEM

NORTH MISSISSIPPI

MURDER & MAYHEM

KRISTINA STANCIL

Kristina Stancil

THE
History
PRESS

Published by The History Press
Charleston, SC
www.historypress.com

Front bottom cover image courtesy of the Mississppi Department of Archives on Flickr.
Front top image courtesy of the Library of Congress.

First published 2018

Manufactured in the United States

ISBN 9781467139366

Library of Congress Control Number: 2018932090

CONTENTS

CONTENTS

ACKNOWLEDGEMENTS

There are many people who came together to make this book possible. First, I'd like to state that if not for my friend and fallen officer Taylor Segura of the Terrebonne Parish Sheriff's Department, I would not be writing this book or attempting to achieve my dream of being a criminologist. It was his suggestion that there were more jobs within law enforcement that I could do that did not require me to meet the physical requirements of being a police officer. Shortly before his death, we discussed options for me to achieve a dream we both shared since we were children.

My Aunt Patricia Y. Dawson (Aunt Tricia) was the first to recognize and accept my interest in things that were not considered "ladylike." Shortly before I turned sixteen, Aunt Tricia acquired a Mannlicher Carcano bolt-action rifle. When my family visited her, not only did she show it to me, but she also allowed me to hold it. She explained the history of the rifle, and we discussed the implications of its use with respect to the JFK assassination, such as the skill of a sniper using the stiff bolt action of the rifle. Her purpose was not just to be the "cool aunt" but to educate me about rifle safety, as well as encourage me to always seek the truth. She has always supported me, had my back in finding my own path to happiness and taught me to not allow other people to think for me. If not for her, I wouldn't have such an awesome collection of music or such a thirst for knowledge. I will be eternally grateful, not just as her niece but also as her friend.

Last but certainly not least, thanks go to my mom, who always told me to keep writing.

INTRODUCTION

Mississippi has a bloodthirsty history. The state has the dubious distinction of being the first in the fledgling United States to house not one but *seven* confirmed serial killers. The first active serial killers in the United States, known as the Harpe Brothers, fought in the Revolutionary War. The Harpes—who were, in fact, born cousins—had become addicted to the bloodlust they had experienced in wartime. They would briefly team up with Mississippi's third serial killer, Samuel "Wolfman" Mason. The Harpe Brothers and Mason were ruthless and hunted at a time before the Wild West gunslingers began earning notoriety—more than a century before H.H. Holmes built his infamous murder hotel in Chicago.

The Harpes and Mason were only the first of many serial killers who preyed on the residents of Mississippi, although, as with the serial killers prowling the state in the twentieth century, their territory also reached outside the boundaries of Mississippi. Two such modern serial killers, the Cross Country Killer and the Red Head Murderer, shared a similar victimology: the prime targets for both serial killers were young women with red hair.

Serial killers are frightening, but perhaps even more disturbing is how much blood has been shed throughout history because of hatred. Decades before the civil rights movement began making the news, African Americans and those who supported their rights to equality were often picked off with as much notice as someone swatting a fly. In most hate crime cases, the mutilation and humiliation suffered by those who supported equal rights rivaled that of many serial killers. Those who were charged with upholding

Welcome to Mississippi. *Wikimedia Commons.*

the law were often the very people who were carrying out the crimes. In at least two cases, a sheriff and a state legislator murdered people who sought equal rights.

Perhaps the most notorious crimes to happen in Mississippi occurred during the civil rights era. Only a few of these killings happened in North Mississippi. However, the Freedom Summer Murders happened over decades. The three victims were a part of the movement known as the Freedom Summer, a time in the early '60s when young people from the North ventured to the South to register African Americans to vote. At the time, Mississippi did not allow African Americans to vote, and all juries were white. This made it almost impossible to get convictions on cases of white-on-black crime. The murders of these civil rights activists were so infamous they became known as the "Mississippi Burning" murders. A movie by that name made in the 1980s starring Gene Hackman dramatized the murders, coverup and the search for justice. It would take decades for the families to receive any justice. This movie is so haunting because its horrific scenes are based on actual events.

Having moved to this state rather than being born to it, I was treated at times as an outsider looking in by local law enforcement when researching these cases. Much of the writing that has previously been done on these cases, especially concerning the subjects covered in the "Hate Crimes" chapter here, was slanted with the view of people coming in from the outside to research. We are often treated as if we are questioning and condemning the people of Mississippi for the actions of the minority.

By using the website Area Vibes, a site dedicated to grading areas on an A-F scale on subjects such as crime, employment and cost of living, I compared the largest city in North Mississippi (Tupelo) with other cities nearby. I chose Jackson, the state capital of Mississippi; the popular Biloxi on Mississippi's Gulf Coast; Memphis, Tennessee; and Birmingham, Alabama. The crime ranking for all the cities except Tupelo is an F. In comparison to these cities of near size and geographic area, Tupelo was given a B- in the crime category.

POLITICAL ASSASSINATIONS

Powerful political figures are often targets of violence, and that was just as true in the eighteenth and nineteenth centuries. In the northern region of Mississippi, two murders occurred that were political in motive. William F. Tucker was murdered in 1881, and in 1889, William Clark Falkner was murdered shortly after being elected to the state legislature. Both were well-

A plantation in 1800s Mississippi. *Wikimedia Commons*.

respected officers who had served in the American Civil War. Tucker retired as a general, while Faulkner served as a colonel in the Second Mississippi Infantry of the Confederate army. He would later become known as the "Old Colonel" to differentiate him from his great-grandson, who was named after him.

RED SHOES

Red Shoes was a Choctaw Indian chief in the 1740s. At the time, the Choctaw Indians held a large expanse of land that encompassed much of Mississippi and parts of western Alabama. Red Shoes wanted to capitalize on the possibilities of dealing with the European settlers. Trading their furs and goods with those who were venturing into their territory provided the Choctaws with the desirable European currency that would allow for the chiefs to secure items that were so desperately in need in the lean winter months. There was the added benefit that in dealing with the French, they would be defended against the larger Indian tribes of the Chickasaw and Creek, who would often raid the smaller tribe for slaves.

The Choctaws eventually became disillusioned with dealing with the French due to their inability to uphold their end of the trade agreement. The officials at the French encampment changed or became mismanaged either by greed or simply because the person was poorly chosen and unable to meet the expectations of the job. The Choctaw hunters often came away empty-handed after months of hunting and collecting furs and skins. They found what they needed by trading with their former enemies, the Chickasaws and Creeks. This would send them into British settlements that backed the larger tribes. The last straw seemed to be when one of the leaders felt slighted by the French for not paying tribute to him. Many of the Choctaws preferred to deal with the British, despite what the leader thought. Red Shoes was not born to the right of being chief. He was a low-born brave who fought so bravely that he made his way into the hierarchy of the tribe. He was not one of the top chiefs. Red Shoes led the smaller faction of Choctaws that led the British-supporting tribe.

In June 1747, Red Shoes took a party to protect traders, but he did not return. As a noted warrior who had fought his way from being on the lowest rung of Choctaw braves to a beloved chief, his faction was a threat to the French. If he were to rebel against the high chief of the Choctaw Nation, he

Left: Flag of the Choctaw Nation. *Wikimedia Commons*.

Below: Choctaw Eagle Dance. *Wikimedia Commons*.

had the fighting prowess and support that could very well succeed in a coup, as the French believed. If Red Shoes succeeded in becoming the high chief of the Choctaw Nation, trade with the French would cease. The French would lose the valuable trade of deerskins and furs, as well as the battle-tested braves who knew the territory and would be indispensable to them if the British declared war on them. They would lose the desperate advantage that the Choctaws had in their fighting technique, geographic knowledge and history of dealing with the other Indian tribes.

For Red Shoes, the well-being of his tribe was of the utmost importance. He fell ill on June 23, 1747, and he did not know what was wrong with him. He did not want the members of his riding party to become infected. He

certainly did not want to take back what he had to the rest of the tribe. So, he ignored protocols for the chiefs of the Choctaw Nation and kept only one retainer to care for him. His hope was to contain his illness. The man he asked to stay with him was most likely his most trusted warrior, but he was also the man whom the French had paid to betray him. While Red Shoes was ill, the man poisoned him. After his assassination, the murderer escaped.

When the French received confirmation that Red Shoes had been killed, they immediately sent forces to attack the Choctaws who rallied behind Red Shoes. The smaller tribes were in mourning for their revered leader, and the French took advantage of this. Many of the Choctaws' tribal towns fell to the French. The Choctaws who supported Red Shoes waged a valiant attempt to avenge their fallen leader. Eight hundred warriors attempted to regroup but were also hunted down and murdered. The murder of Red Shoes plunged the Choctaw Indians into a civil war over whether they would trade with the British, who allegedly always paid something for goods received, as opposed to the French, who left them empty-handed and were responsible for the murder of a beloved chief and superb warrior.

The Choctaw Civil War lasted from 1747 to 1750. Red Shoes' murder ignited the war, but after the Choctaws learned of how he died and why, it helped transform the Choctaw Nation. It allowed the nation's leaders to work for a more united tribe. Red Shoes was purported to be a hero for the Choctaw Nation, as it was discovered that his attempt to trade with the British was not for his own personal gain. His advisors revealed that he had a vision that the Choctaws would benefit from the advantages of the Europeans and be strengthened as a nation so that they would not fall under a foreign sovereign rule.

WILLIAM F. TUCKER

William F. Tucker was a soldier during the American Civil War. He joined the Mississippi Confederate army as a captain but quickly rose through the ranks to become a brigadier general. Tucker survived a career-ending wound during the Battle of Atlanta and was then elevated to commander of the southern Mississippi and eastern Louisiana infantry regiment.

After the war, Tucker returned to Okolona, Mississippi, and resumed his career as a lawyer. Tucker prospered in this profession and was highly involved in the reformation of the politics of the 1800s. He was elected twice to the

state legislature. A participant in the violent upheavals and controversies that marked Mississippi politics in the 1870s, he served in the state legislature in 1876 and again in 1878. He was one of the members of the committee that initiated impeachment proceedings against Governor Adelbert Ames. Ames was initially appointed by Congress, and he was supported by Reformists and newly freed African Americans. Despite laws that were imposed by the federal government allowing the former slaves to vote, Tucker and his fellow like-minded politicians were adamant about returning political policies and laws to the same state they were prior to the Civil War.

Tucker was involved in a case full of animosity against two unnamed men at the time of his assassination. Witnesses reported that two men broke into his home and killed him. Even though two men were arrested in connection with his murder, no one was ever charged with the crime. Popular opinion at the time was that the court case was leaning in Tucker's favor, and his opponents hired professional assassins to kill him.

WILLIAM CLARK FALKNER

William Clark Falkner's legacy as the inspiration and namesake of his great-grandson, literary legend William C. Faulkner, is well assured.

The Old Colonel was a writer himself and the driving force behind his great-grandson becoming an author. In fact, it is alleged that William C. Faulkner once said, "I want to be a writer like my great-granddaddy." At least two of literary giant William Cuthbert Faulkner's books feature Civil War officers based on stories passed down about his great-grandfather. His influence can be felt in characters like Colonel John Sartoris in the novels *Sartoris* and *The Unvanquished*. The Old Colonel is considered an integral part of the fictional Yoknapatawpha County.

William Clark Falkner. *Tippah County Historical Society.*

The irony of Falkner being murdered is that he was once indicted for murder himself. A man named Robert Hindman accused the Colonel of slandering him. He attempted to murder Falkner by shooting at him twice. Both shots missed, and in the midst of a fight, Falkner pulled a knife and

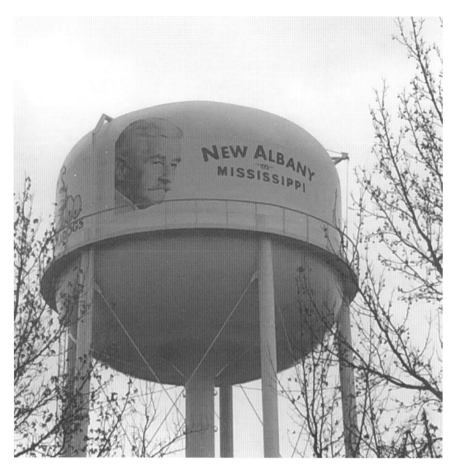

The William Clark Falkner water tower in New Albany, Mississippi.

stabbed Hindman to death. After the Colonel was acquitted on the basis of self-defense, one of Hindman's friends challenged the Colonel to a duel. A gentleman of the Old South, had the Colonel refused, his honor and that of his family would have been at stake. The family would have been considered cowardly. He accepted the duel and won. The Colonel was again put on trial for murder. As this was the Old South, the jury was made up of white gentlemen who thought the same as the colonel: honor was at stake. It was a matter of kill or be killed. He was found not guilty, again due to it being self-defense.

A few years after both duels, he ran for and was elected to the state legislature in 1889. On the night of the election, a former business partner

in the railroad business, Richard Jackson Thurmond, shot and killed the Colonel. Thurmond was arrested and charged with manslaughter. He was allowed to post bail in February 1890. The trial ended a year later with a not guilty verdict, but questions linger: Why did Thurmond kill Falkner? What evidence was presented in the case that made the jury acquit Thurmond? The public may never know since the records from the case in Ripley, Mississippi, are missing. Unless there are newspaper articles kept in personal family archives, the public may never be privy to the details surrounding why Thurmond killed Falkner.

The information available notes that Richard Jackson Thurmond, known by the names Captain Thurmond and R.J. Thurmond, ultimately moved to North Carolina. He is said to have died on November 18, 1907, in Mecklenburg County, North Carolina, at St. Peter's Hospital in Charlotte. It does not list a cause of death, though presumably old age. He was seventy-eight years old when he died and sixty when he killed the Colonel.

PART II

HATE CRIMES

Since when did the phrase "pursuit of happiness" become a trigger word for murder? These inalienable rights that the Declaration of Independence outlines and our forefathers fought did not gloss over the lives of transgender people, who are assaulted and murdered not just in middle and southern Mississippi but throughout the world; hate crimes know no gender, race, religion, orientation or identity. Nor are such people any less worthy of the rights Thomas Jefferson outlined centuries ago.

Bigotry seems to be one of the primary reasons for bloodshed in Mississippi. The civil rights era was a particularly violent time in our nation's history, but in Mississippi, the mistreatment of the African American community began centuries before Dr. Martin Luther King Jr. preached about the equality of all races. Lynching and murders were common practice in Mississippi, not just to members of the African American community but also seen in the murders of Andrew Goodman, James Chaney and Michael Schwerner in the summer of 1964, all of whom were murdered because they were attempting to aid African Americans in Mississippi to register to vote. Schwerner's wife complained that the only reason the disappearance and murder of the three men made any news at all was because Freeman and Schwerner were white northerners. The papers rarely mentioned Chaney, who was the sole black victim murdered in what became known as the Freedom Summer Murders. It would take decades before anyone truly paid for the crime. Samuel Bowers was the instigator and called for the murders of Schwerner, Goodman and Chaney. Edgar Ray Killen, a

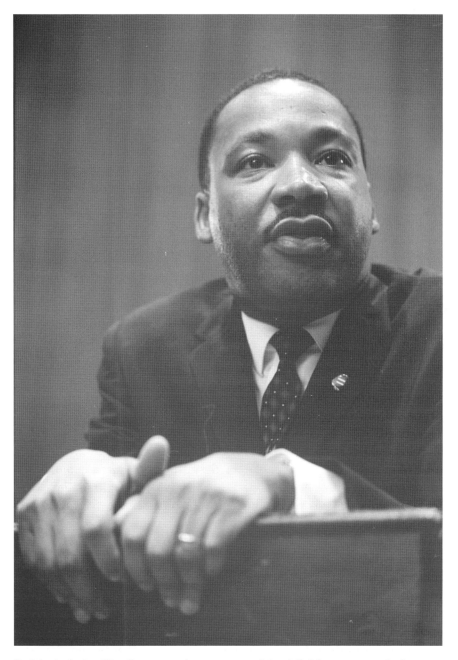

Dr. Martin Luther King Jr. was a major proponent of the civil rights movement in the South, using nonviolent protest to combat the often violent bigotry against African Americans. *Library of Congress.*

pastor, was believed to be the trigger man and the point man in the crimes. He was a member of Bowers's Klan splinter group and was convicted in 2006. Killen died in Parchman in January 2018.

Hate crimes may shift focus, but they are still just as active and senseless in the new millennium. In this chapter, many of the players involved with the murders in the 1960s are connected to events that happened twenty or more years later.

RICHARD BARRETT

Early in the morning of April 22, 2010, firefighters discovered notorious white supremacist Richard Barrett dead. Barrett had been beaten and stabbed thirty-five times. His killer had attempted to set his home on fire as a forensic countermeasure to hide the evidence of the murder before fleeing the scene of the crime.

Richard Barrett was a lawyer based in Mississippi. He was a very vocal member of the white supremacist movement. He also claimed to be a leader in an alternative branch of the movement known as the Skinheadz. It is perhaps not surprising to discover that Barrett's murderer was a young African American man.

Barrett's claim to fame was being a vocal advocate for white supremacist Edgar Ray Killen. Killen was suspected in the murders of the three civil rights workers during the Freedom Summer movement. Despite Barrett's vocal support and legal advice, he was not Killen's actual attorney. Perhaps Killen believed the rumor that Barrett was a closet homosexual (in these rumors, Barrett excused his inclinations for young African American men because he did not see them as human, so "it did not count").

In 2004, Barrett organized a booth at the Neshoba County Fair to garner public favor for Killen since the federal government had indicted him for federal hate crimes. It was also to garner support for their joint belief in the superiority of the white race. One of Barrett's goals was to have Killen shake hands with the public and present him as a southern gentleman and member of the clergy, ignoring the fact he had been previously connected to Samuel Bowers, a leader of the Mississippi Ku Klux Klan, who had hands-on involvement in the killing of Goodman, Schwerner and Chaney, among many others. Bowers was also convicted on hate crimes rather than state's mandate on the crime of murder. All his crimes were racially motivated,

Edgar Ray Killen, convicted of hate crimes relating to the Freedom Summer Murders. *Mississippi Department of Corrections.*

and since so many decades had passed since the actual crimes, the charges Bowers was convicted of were federal.

Barrett hoped that people who visited his booth would sign a petition in support of Killen to aid the defense against his participation in the 1964 murders. Perhaps in a moment of clarity, on advice of other legal counsel or simply proximity to what author John Safran called "the predominately African-American Jackson," Killen chose not to show up. Considering the charges, it was perhaps in Killen's best interest to distance himself from someone like Barrett, who was quite vocal about his beliefs. This is in contrast to the Klan mentality presented by the splinter group that Killen belonged to and Bowers led.

Barrett published a memoir entitled *The Commission*, which was more like a manifesto of his hate, in which he tried to advocate his reasoning behind his belief that any person not white (and especially black) was inferior. He further stated that he believed minorities were like animals and advocated both abortion and sterilization to limit numbers.

Safran investigated the theory of Barrett's alleged homosexuality in his book *God'll Cut You Down*. He interviewed Barrett as a part of a documentary series he was developing called *Race Relations*. Safran also interviewed Vincent Justin McGhee, who would be convicted of murdering Barrett on April 22, 2010. McGhee set the house on fire to try to hide the violence he did to Barrett—the trial revealed that Barrett was stabbed thirty-five times and suffered blunt force trauma to his head and fractured ribs. The excessive amount of trauma inflicted on Barrett's body seems to indicate more than just self-defense. The number of stab wounds and the use of a heavy object to batter the body before or after the stabbing implies extreme anger.

Safran claimed that he befriended McGhee, but in an interview with the American-based podcast *True Crime*, he said that McGhee began to threaten him. He also tried to extort money from him and claimed certain gang affiliations that, he said, could come find Safran in whatever hotel he was in to take the money. Interviews with McGhee's sister, friends and acquaintances revealed that the man had very few friends. He also did not have any affiliation with any gang.

Safran would go on to discuss the initial plan of defense for McGhee's defense team. The claim was that Barrett had dropped his pants and propositioned McGhee. Even though McGhee claimed that he had been propositioned when he was arrested, Safran noted that the defense was dropped despite Safran's own belief that it would have made his actions more sympathetic to the jury.

It is Safran's belief that homosexuality was considered less of a taboo compared to the revelation that Barrett had been involved in a mixed-race partnership. Safran likens Mississippi to the Twilight Zone: a bizarre, backward state that drags its feet in advancing equal rights.

Safran informed the listeners of *True Crime* that he believed the outcome of the McGhee trial, in which he was found guilty of murdering Barrett, would have been found different if he had stuck with the claim that he was defending himself against Barrett's sexual advances.

SAMUEL BOWERS

Noted white supremacist Samuel Bowers was born in New Orleans in 1924. Bowers was the grandson of a wealthy plantation owner on one side and a highly vocal separatist legislator in the House of Representatives on the other. While this was the case with many southern men, Bowers was different. He was veteran of World War II. Bowers briefly studied at Tulane and would transfer to the University of Southern California at a time when a more anarchist form of white supremacy was on the rise.

Many young rich white males had a similar upbringing as Bowers, and several probably joined the Ku Klux Klan or the Night Riders (white supremacists who relied on intimidation rather than violence). What was it, then, that pushed Bowers further into becoming an excessively violent and charismatic leader of a splinter cell that would be responsible for at least four known murder victims? Bowers may have had hands-on experience in a bombing, but did he plan the murders of Michael Schwerner, James Chaney and Andrew Goodman? These three men were civil rights workers associated with the Freedom Summer. One of Bowers's henchman, Edgar Ray Killen, was the point man in Liberty, Mississippi. Killen, working with the local Sheriff's Department, orchestrated their arrests, and while they were in jail, being denied their rights, the sheriff waited for word from Killen, who was waiting on Bowers.

After three days, the men were released. But they were followed by Killen and several other men, allegedly including the sheriff, and hunted. Once they were in an isolated spot, they were pulled over again. The three men were taken to the Old Jolly Farm and murdered. Another Klan member drove their car to the place where it would be discovered and set it on fire—all a part of Bowers's plan to bring the Federal Bureau of Investigation (FBI) into Mississippi. Since the three men were from the North, he knew that the FBI would spend more time searching for the bodies than had they been three locals. After all, African Americans and those who treated them like equals had been murdered for years without federal involvement. Bowers wanted to make a statement. He wanted to create a race war. His goal was to bring the whole nation into accord with the way things were done in Mississippi at the time. For instance, a white woman associating with a black man could be jailed, and her ability to call herself a white woman could be taken from her—she could be "reclassified" as black and treated as such.

A member of the Ku Klux Klan, Bowers convinced several members of his local branch to leave and form their own group. There is no exact date as to when Bowers officially joined the Klan, but his very heritage suggests

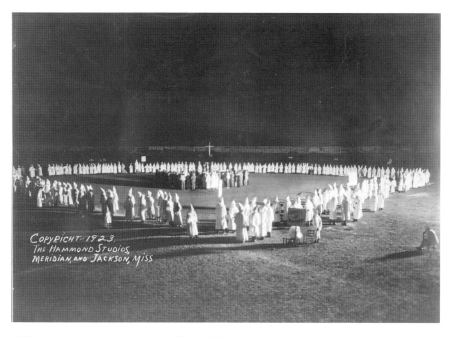

A Klan initiation rite in Mississippi. Samuel Bowers was an imperial wizard of the Mississippi Klan and the first grand wizard of the White Knights of the KKK. *Library of Congress.*

that he was indoctrinated early in life. He cofounded the White Knights of the Ku Klux Klan as a more reactionary organization in response to the growing civil rights movement. On February 15, 1964, he was sworn in as the "first grand wizard" of the White Knights of the KKK. Bowers was charismatic enough to convince others who, up until 1964, only believed it was their God-given right to be the superior race. These otherwise God-fearing men had primarily used intimidation tactics against white people who attempted to treat black people with common human decency, as well as, in rare occasions, beating black men who did not follow the status quo. Lynchings and torture were used as last resorts when they believed black men had disrespected a white woman. Bowers looked at murder as a God-given right, but he also convinced his followers that white men were the chosen soldiers of Christ to fight his enemies—perhaps in a twisted interpretation of the theory that black people were so marked because when Cain slew his brother, Abel, he was punished by God and turned black to mark the evil that was in his soul.

Bowers believed that communists were behind the civil rights movements. He believed that the KKK of the 1960s was too passive. He convinced two hundred Klansmen to join him a more radical faction. Bowers imposed a code of secrecy, believing his group to be protectors of law and order of the South. His version of law and order was more akin to the treatment of runaway slaves and abolitionists during and prior to the American Civil War. According to the Encyclopedia of Alabama, runaway slaves were usually horsewhipped repeatedly for their actions. If they still attempted to run away, they were sold. The encyclopedia notes that white people who were harboring runaway slaves were fined or jailed. In extreme cases, at least in those cases shown in the movies, abolitionists or whites who harbored runaway slaves could be hanged.

Thomas Tarrants—an ordained minister during the Ole Miss Riot, Freedom Summer Murders and the bombing that killed National Association for the Advancement of Colored People (NAACP) activist Vernon Dahmer (1963–66)—saw himself as occupying the same unique space as Bowers in the counterrevolution against integration and desegregation: that of a "holy warrior." Bowers would often bastardize portions of the Bible to entice members and rationalize the course of action his faction would take against those who opposed their views. Bowers believed that anyone who supported the civil rights movement was a godless communist. It was the responsibility of all God-fearing white men to stand up for their country by keeping the whites in power.

Freedom Summer Murder Memorial. *Wikimedia Commons.*

Author and journalist Stuart Wexler discovered that Delmar Dennis, the FBI's informant for the Freedom Summer Murders, told investigators that the average man in Mississippi was not smart enough to know he was getting duped. Wexler further wrote that Dennis claimed that Bowers admitted he twisted the Bible. Bowers allegedly said, "I have to use *Him* for my own cause and direct his every action to fit my plan." If Delmar Dennis were found to be a credible witness for use of the prosecution, then Bowers would be seen as being fully aware of his actions; even though he might be a sociopath, he knew that he had to convince others of his interpretation of the Bible.

At some point in college, Bowers embraced a radical interpretation of Christian ideology that devalued minorities as subhuman and viewed people of the Jewish face as Satanic conspirators against Anglo-Saxon whites. Bowers is quite possibly an early homegrown terrorist who was also extremely secretive about his radical, militant, racist views, thus lending credence to John Safran's belief that "Mississippi is a place of secrets." For Bowers's White Knights, the members who joined were bound by an oath of secrecy. Bowers had to "spin his ideology" in such a way as to incite his conventional Christian Klan members to join him in his quest for violence.

If readers examined the killings of Michael Schwerner, Andrew Goodman and James Chaney as crimes of religious terrorism, the events could be even more disturbing.

Charles Marsh believed that Bowers's religious ideology was formed by his experience in World War II. Marsh believes that Bowers in 1955 was already suffering from what can only be described as religious hysteria. He described it as "a moment of mystical intensity"—that Bowers believed God had spoken to him. From that point, he always carried a Bible, began every Klan meeting with a prayer and insisted that all his Knights have a "solemn, determined spirit of Christian reverence [that] must be stimulated at all times."

The Christian Identity movement began innocently enough in Victorian England, as people believed that Christians were God's chosen people, not those of the Jewish faith. It would become bastardized in the United States when the idea was seized by the Klan and used to make it the largest fraternal order in the 1920s, with membership numbers in the millions.

For the twisted ideology used by the Klan, Jewish people were demoted even farther from God's chosen to that of Satan's spawn. It was believed that they were sent to lead God-fearing people away from the righteous Christian path.

Men like Bowers—and, in retrospect, Charles Manson, who was or shortly would be active in his own attempts at starting a race war in California— believed that they were destined to be soldiers in a coming "end of times race war." Many of these ideologists stockpiled weapons and food in preparation. Bowers, in relation to the Freedom Summer Murders and the bombing of Vernon Dahmer's store, so zealously believed that if they willingly engaged in acts of violence, they could speed up the coming of Armageddon.

Bowers shared the same ideology as JB Stoner, who founded a church based on the belief that Anglo-Saxon whites were on a religious crusade to battle the minions of hell, which meant all nonwhite Christians. Stoner was perhaps even more disturbed than Bowers. Stoner believed that Hitler had not gone far enough to eradicate the Jewish people. It is important to note that Michael Schwerner is believed to have been, in their vernacular, a "Northern Jew" (a man of the Jewish faith who lived in the North and had come to "forcibly" impose his views on the people of Mississippi). This was a transgression that Bowers and many of his followers felt was worthy of damnation.

Stoner was considered so radical and unhinged that the Klan groups in Tennessee forced him out. This seems to be yet another reason for Bowers's keeping his religious hysteria to himself. This also underlines his forcing

members to accept a code of silence. Delmar Dennis confirmed this when he said about another private conversation with Bowers, "He was trying to create a race war by engendering hatred among whites in the same manner as it was fermented by leftist radicals among blacks."

It is believed that Bowers and Dennis had this conversation in 1964. Perhaps it's a coincidence that at the time Bowers was attending USC the radical version of the Christian Identity movement was gaining a following in Southern California. Although it is unknown whether Bowers attended the CI movement sermons at the time, it is known that while studying at USC and after serving in World War II he began studying both religion and Nazi ideology in the late 1940s.

Twenty years after attending USC, Bowers was a confirmed supporter of Wesley Swift's Christian Identity movement. Bowers would extend his operations to target the Jewish community and took up where Stoner had left off in the 1950s with temple bombings. Bowers could not get most of his followers to target non-Christian whites because, after all, these were fellow white men. These southern-born men believed black activists' and the federal government's interference in trying to force them to accept African Americans as equals was the true evil.

After the Civil Rights Act of 1964 and the Voting Rights Act of 1965 were successful, many of Bowers's followers left the Klan. Once he was left with his most ardent supporters, he was able to refocus his attentions on attacking members of the Jewish community.

The Freedom Summer Murders occurred on June 21, 1964. Bowers most likely had begun planning these murders as early as the first part of May. Scholars find premeditation in the Freedom Summer Murders, as well as analyze the great lengths to which Bowers and his followers, primarily Edgar Ray Killen, went in hiding the bodies under the dam at the Old Jolly Farm. Many Klan murder victims were seen as trash and treated as such when bodies were disposed of in swamps and marshy areas. When the FBI came to Mississippi to search for the three civil rights workers, agents dredged the marshes and swamps, recovering not just the three workers they were seeking but also a large undisclosed number of the Klan's victims.

Such a discovery was odd, even though the burnt-out car was so easily discovered and was a standard motive of the Klan. Bowers's reasoning seems to have been that the FBI would have found the remains of the burnt-out car and would spend a lot of time looking for the bodies. Bowers hoped these killings and other terror attacks would even bring Dr. Martin Luther King Jr. to protest in Mississippi so he could be targeted too. He believed that Dr.

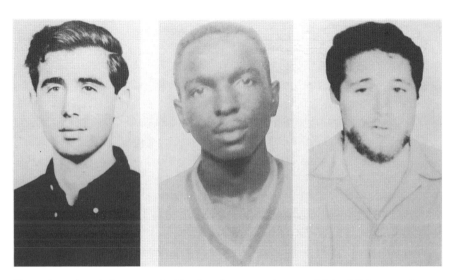

Photos from the missing poster for Freedom Summer volunteers Michael Schwerner, James Chaney and Andrew Goodman. *Wikimedia Commons.*

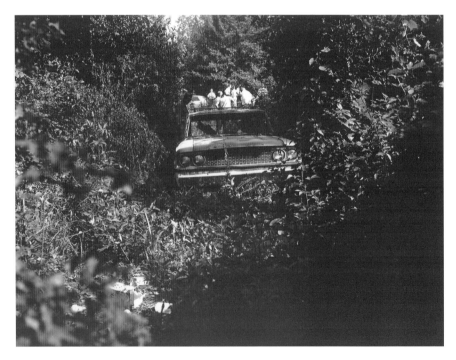

The car driven by the Freedom Summer murder victims was discarded in a place to ensure that it was recovered. *Wikimedia Commons.*

King's death would cause massive rioting and ignite the race war he'd been kindling. It was consistent with the activities following the failed attempt on Dr. King's life after the Birmingham church bombing in 1963. Perhaps these served as foreshadowing to the actual events of the 1968 assassination of Dr. King in Memphis. There were riots, as Bowers had believed would occur. He believed and hoped that it would cause national rioting.

The FBI discovered that the people who jailed, kidnapped and killed Goodman, Schwerner and Chaney were not followers of Bowers's ideology. Although Edgar Ray Killen was very active in the white supremacist movement, his participation was to make the victims pay for attempting to change the way of life that he and his friends felt was right in Mississippi. To make it even more convoluted (and connected to the other items in this chapter), many of Bowers's followers who organized the Freedom Summer Murders had also participated in the violence against the National Guardsmen sent to protect James Meredith as he attempted to enroll at Ole Miss in 1962. They incited the crowd and were complicit in the murder of Paul Guihard, the French journalist who came to cover the groundbreaking event.

These people were diehard believers in the ways of the Old South—to them, any federal involvement in a forced change of the way things had been in Mississippi for centuries was worthy of damnation. These same men had been indoctrinated since birth to believe that the Northern military occupation during Reconstruction was a travesty of the highest order.

Attempts (or at least veiled attempts) were made to punish perpetrators in the murders in the 1960s. Documents were classified for decades in an attempt to protect those involved with the killings, in the hopes that by the time the documents were declassified, the witnesses and perpetrators would have died.

It was not until 1998 that the federal government was able to prosecute Bowers for the 1966 murder of NAACP activist Vernon Dahmer, who died as a victim of a bombing. Dahmer allowed African Americans to vote in his store.

Bowers, however, would not do much time, as his age and health had taken their toll. He died of cardiac arrest one year after his accomplice, Edgar Ray Killen, was convicted of manslaughter in the Freedom Summer Murders. Killen would be the last conspirator convicted in the murders. (Bowers was convicted in 1998, but it would take until 2006 for Killen, who was physically involved in the murders, to finally be convicted.) Curiously, a man with a fictional name and address claiming to be Bowers's brother

came to visit him repeatedly at Parchman, the Mississippi State Penitentiary. No investigation has ever revealed that Bowers had a brother.

These events might have inspired the plot in John Grisham's *The Chamber*. The movie adaptation also starred Gene Hackman, who had played an FBI agent in the movie version of Freedom Summer Murders, *Mississippi Burning*. In the Grisham adaptation, Hackman plays a Klansman convicted of bombing a Jewish lawyer's office. The lawyer lives, but his two young sons died in the blast. For Grisham's tale, there was someone else who was involved in the bombing, but after visits from a mysterious man, Hackman's character refuses to talk about the events of the bombing and takes full responsibility. (Delmar Dennis's reasons for turning informant for the FBI could also have inspired Grisham to create a character in a different work known only by the name "Mickey Mouse"—when he calls to inform about an attempted bombing at character Jake Brigance's home in the novel *A Time to Kill*, the mysterious man hesitates in giving his real name and gives instead the name of the cartoon character he had tattooed on his arm.)

Could Bowers as the leader of a Mississippi splinter group have orchestrated someone else's involvement? Stoner seems a likely conspirator, but he did not have the charisma to inspire those to rally to the increasingly violent actions of the Klan. He is likely, but would he have had the influence and power to force Bowers to remain silent?

JAMES MEREDITH VERSUS OLE MISS

Dr. Martin Luther King once said, "Injustice anywhere is a threat to justice everywhere." Mississippi did not seem to get the memo for several decades.

James Meredith, an air force veteran and honor student at Jackson State University, returned to Mississippi feeling he was destined to make a change for himself, his wife and their year-old son. After being stationed in Japan and after a brief visit with his wife's family in Indiana, Mr. Meredith drove back to Mississippi. He believed that he had been born with something special, and that something special had to do with black people achieving equality not just within Mississippi but in the rest of the world. Mr. Meredith would fight to enroll at Ole Miss, which at the time was known as the "rich white school." He would also enter politics, and even though he was a Republican, he would hold a special affinity for John F. Kennedy after hearing his debate with then vice president Richard Nixon. Meredith's intelligence and his

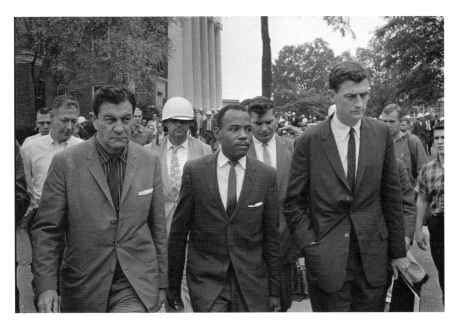

James Meredith walks over the rubble in the aftermath of the Ole Miss Riot. *Wikimedia Commons.*

ability to see the good people of different political parties were trying to do would aid him well, as he would often accept appointments to work in the offices or cabinets of Democratic politicians.

During the drive to Mississippi, Mr. Meredith stopped to hear Dr. King speak at a church. The sermon would so impress him that one year later—when Dr. King came to rally support for the students who were arrested because they were protesting the fact that African Americans were not allowed to use the Jackson Public Library—Meredith was not afraid to be seen with Dr. King. He learned that this more vocal group had invited Dr. King to come speak to its supporters, but its members were all afraid to pick him up from the airport. As a military veteran, and holding the belief that all men were created equal, upon hearing that Dr. King and two advisors had been left to wait for more than two hours at the airport, he decided to act. He was not afraid to be seen with Dr. King or pick him up and drive him to the church where he would be speaking. Mr. Meredith revealed that the advisors were annoyed and initially believed that they were with the group that had promised to pick them up. Mr. Meredith was not afraid to fight and would finish a fight if someone confronted him, but he was very vocal about not seeking trouble.

Even though Dr. King seemed tired and put out that he had to wait for some time for someone to pick him up, he still was reserved and wished respect for all people, despite the irritation that his aides showed to Mr. Meredith as he dropped them off at where they were supposed to be. Mr. Meredith's friendship with Medgar Evers quite possibly made his name known to Dr. King.

Mr. Meredith attended the sermon Dr. King delivered later that night. The subject regarded how to nonviolently handle the situation at hand, as well as the nonviolent boycott that had been waged in support of the students who had been arrested by the Jackson city police. He may or may not have known that Mr. Meredith had been the one who had led the nonviolent boycott at Jackson State, but he did not single him out. When Mr. Meredith attempted to ask how he should have handled abuse at the hands of the faculty (such as the university president slapping one of the female student protestors), other than the standing their ground and not turning it into a brawl, the crowd turned on him. Dr. King attempted to answer the question, but the crowd got louder and drowned him out. As Dr. King attempted to calm the crowd and regain order, as he admitted he wanted to answer the question, the crowd refused to let him. Several men overtook Mr. Meredith and threw him out of the church. They then barred the door to keep him from returning. These people who had so cowardly abandoned Dr. King at the airport because they were afraid of being seen with him were now turning on him and his goals for a nonviolent hope to earn equality. They did not want Dr. King there for his intelligent, experienced advice. They only wanted him there for his fame and were using his attention to advance their own agenda.

Mr. Meredith, as advised by his own father, as well as inspired by Dr. King, wished to do things rationally. He knew that protesting on the campus of Jackson State, rather than venturing into downtown Jackson, was safe. It did also receive media attention, especially when one of the female students protesting was slapped by the university president. The university police confirmed that leaving the campus and invading "enemy territory" would be infinitely more challenging than a verbal altercation—Mr. Meredith had already attempted to warn his predecessor as president of the Jackson State Veterans' Club to this effect. Going into downtown, the all-white police force would turn loose vicious dogs that they had trained to attack nonwhite people. The former club president and his nearly 150 followers were attacked by the police with the dogs, firehoses and tear gas, an event that was covered internationally. In his book, Mr. Meredith noted that the

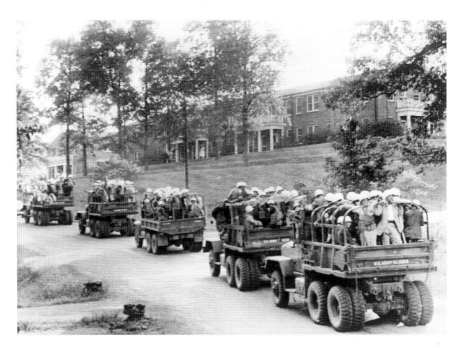

U.S. marshals roll across the Ole Miss campus. *Wikimedia Commons.*

images splashed across the newspapers were so horrendous that the mayor of Jackson received a telegram from Russian premier Nikita Khrushchev protesting the use of such force.

Mr. Meredith's book, *James Meredith vs Ole Miss*, primarily deals with his life up to the battle he fought to enter Ole Miss and how he was introduced to Medgar Evers (who was later murdered by his stalker, alleged Ku Klux Klan member Byron De La Beckwith), who aided him into getting someone from Thurgood Marshall's law office to defend him in his battle to enter Ole Miss. He also revealed that Mississippi assistant state attorney Ed Cates, who worked closely with Governor Ross Barnett in their attempts to keep Mississippi violently segregated, would ultimately be investigated for murder himself.

It is important to note that according to the way Mr. Meredith's book is written, he was not on campus during the riot at Ole Miss. He was sequestered in an apartment on Dillard Campus in New Orleans, Louisiana, as his case was in federal court, under the guard of U.S. marshals, members of the U.S. Justice Department. The Justice Department watched the lower court cases but did not get involved initially, despite the interest U.S. Attorney General Robert F. Kennedy had in integrating the South.

Mr. Meredith, via his association with Medgar Evers and Thurgood Marshall's office, learned that while President John F. Kennedy ordered Governor Barnett to allow him to register at Ole Miss (even threatening to federalize the Mississippi National Guard to force the school to allow him on campus), Governor Barnett was playing both sides. He pretended to agree with the president but wanted him to force his hand so that voters would believe he had no choice but to let Mr. Meredith onto the campus and into the school. Even though Barnett pretended to work with the federal government, he also went on local television promising that Meredith would not be allowed onto campus; at a pep rally at Ole Miss, he even boasted of how he was misleading the federal government and the president.

The Meredith family believed that the Klan was dead in Mississippi, but history has shown that the Klan, while sometimes quiet, is never truly dead. It hides in the weeds like a poisonous snake. (It is this silence that perhaps was the breaking point for Samuel Bowers in creating his violent faction of the Klan.)

Mr. Meredith did not get into the specifics of the Freedom Summer Murders, but there are some veiled indications that he knew that change was coming to Mississippi. When the first Freedom Riders came to Mississippi, he was at the bus station and overheard the way the crowd reacted. He was cautious and remained silent but knew that they would be arrested if they attempted to get off the bus. One onlooker (white) said that they should be killed for interfering with the way things were done in Mississippi—a little foreshadowing to the murders of Schwerner, Goodman and Haney one year after Mr. Meredith began attending Ole Miss.

Mr. Meredith did point out how a mob mentality, despite the positive or negative influence of leadership, will go with the most vocal person within the group, as with his experience with those who claimed to be such ardent supporters of Dr. King. Despite Dr. King's message of peaceful nonviolent solutions to effect change, those who attended his speech reacted violently when Mr. Meredith asked a question the crowd did not like. A charismatic person can read the nature of the crowd around him and incite them to act. This seems to be the consensus of the situation at Ole Miss the night before Mr. Meredith could register.

Even though Mr. Meredith did not go into detail about the night in question—in fact, he skips over the time from before the decision was handed down by the Supreme Court to the day after the riot—it is hard to believe that he was not right there, as so many people, mostly members of the Justice Department and one-third of the marshals sent to protect him, were injured

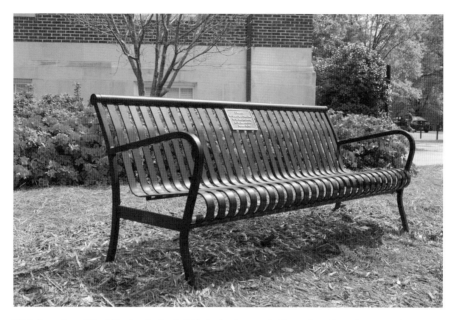

This bench at Ole Miss in Oxford, Mississippi, was dedicated to French journalist Paul Guihard and the unknown other person who died during the riot at Ole Miss in 1962. *Ole Miss.*

during the riot. He must have been there initially. Perhaps it was his calm demeanor and instincts as a former soldier that helped him keep his head and listen to the marshals who were protecting him.

French journalist Paul Guihard was in Oxford, Mississippi, for the moment, covering the integration of Ole Miss for his newspaper, *Agence France-Presse*, since it was the big-ticket item in 1962. However, Guihard at this time was an editor and did not go into the field to cover stories very often, confirming just how big the story was. It is believed that Mr. Guihard was actually *not* working the day that federal marshals attempted to enforce the Supreme Court's decision that Mr. Meredith should be allowed to attend Ole Miss. (As for the moral, financial and academic portion of Ole Miss's requirement, the school had initially shown quite an interest in the letter Mr. Meredith had written about his interest in the school and his status as a veteran of the U.S. Air Force, until the university realized he was black.)

The Supreme Court's decision was so monumental that Guihard's newspaper felt that a member of the staff and a photographer should be there to cover the story. The photographer described the mood of the crowd as tense when they arrived, as it was clear to him at least that the federal government was adamant about Mr. Meredith being enrolled.

The unconfirmed story is that Guihard and his photographer were under the impression that since President Kennedy had stated that force would be used if necessary, they did not immediately go to campus but rather to the Governor's Mansion, where Governor Barnett was interacting with Mississippi's White Council on how to keep Mr. Meredith off campus, as well as what to do with the federal government's threat of force. Guihard even met with the executive director of the White Council, Louis Hollis, and was allowed to file the now infamous story about how the "Civil War Never Truly Came to an End" and that the South was in the midst of "the gravest Constitutional Crisis the United States has known since the War of Secession."

Following this unconfirmed theory, Guihard heard on the radio that President Kennedy had announced that federal agents had escorted Mr. Meredith onto campus; even though he felt they had missed the main part of the story, he still wanted to get some images that could be used, as well as get a few bystander reactions for quotes for his story. Unfortunately, the rioting had started before they arrived. It is believed that it was close to 9:00 p.m., and since Guihard did not want to be targeted by the rioters, he told his photographer to split off. They arranged to meet up at a certain time and a certain place to leave so they could compare notes in relative safety. It is believed that a photographer from *Life* magazine was fearful about Guihard heading in the direction of the main part of the riot, but having previously been in a war zone covering a story, Guihard was not worried. Being white himself, he perhaps felt safe that the rioters were primarily white people who did not want Mr. Meredith on campus and did not want federal interference—surely an anonymous, British-born French journalist would be safer than he was in the war zone he had covered. Some reports believe that this is the last credible source to have spoken to Guihard before his murder.

Twenty minutes after it is believed Guihard arrived on campus, students found him near one of the dormitories and initially believed he had succumbed to tear gas either from passing out or from a heart attack due to his age. The riot kept an ambulance from coming to them, so they were able to get someone to put him in a car to take him to the hospital.

The hospital determined that he had been shot in the back, with the bullet penetrating his heart. It is hard to believe that students at a university with a reputation for strict academic standards would not have mentioned any blood. Even if Guihard's heart instantly stopped from being shot in the back, and even if it did not have an exit wound, there would have been blood on his back, on the ground where he was found or on the back of his suit.

Since this was one of many unsolved murders of the civil rights era, these questions and many others most likely will never be answered. Another question lingers: why was he killed? Was he targeted because he was a journalist who trespassed on the sacred ground of Ole Miss? For those who had seen him at the Governor's Mansion during the White Council meeting and then again at its headquarters, he would have been identified as a reporter.

His article and those who claimed to have supported Mr. Meredith's attempts to enroll at Ole Miss could be considered points of interest—along with those who physically removed Mr. Meredith and refused to allow Dr. King to answer an innocuous question about how to proceed with nonviolence to the abuse suffered at the hands of the protesters who had marched on downtown Jackson. Cleveland McDowell, the second African American student to enroll at Ole Miss, was a lot younger than Mr. Meredith. In his book, Mr. Meredith mentioned meeting McDowell at Medgar Evers's home when McDowell was a high school senior.

The rumor that McDowell was Meredith's roommate in the dorm was not confirmed in Mr. Meredith's book. Mr. Meredith was a husband and father. He had an apartment in Jackson and a large farm in Attalla County, Mississippi, that he had bought from his father. Mr. Meredith did write about how he and his wife had to get an apartment in Jackson so they both could attend Jackson State University. Jackson is more than two hours away from Oxford. Mr. Meredith was very much in love with his wife and would have taken her and their son with him to Oxford.

Mr. Meredith did mention that McDowell was the second African American who attended Ole Miss, but he was not a student for long. McDowell was expelled for carrying a handgun with him on campus. While a gun rack in some southern schools can be expected, as men often hunt after class or they are returning from a weekend of hunting, it stays locked in their vehicles. Ole Miss was alleged to have a zero-tolerance policy on weapons being brought into the classrooms. Mr. Meredith wrote in his book that McDowell was expelled after he graduated from Ole Miss, so considering the age difference (at least six years due to the time between when Mr. Meredith graduated high school and served in the military), it is likely that they spent very little time, if any, on campus together.

Mr. Meredith strongly desired change and seemed to share Dr. King's vision of a nonviolent method of orchestrating change. He seemed quite disappointed that McDowell was expelled. In his book, he questioned McDowell on why he was expelled. In McDowell's version of the events,

several girls on campus refused to leave him alone and would follow him when he left campus. This, in turn, led to some of the boys following him off campus, making him fearful of what they would do to him if they caught him. Mr. Meredith seemed a little put off by this, and it seemed like he did not believe the young man about how all the girls were following him.

This is not to say Mr. Meredith did not respect McDowell—this is simply based on the reality of the time, especially in Mississippi. From his own knowledge, and from the stories his father, Cap Meredith, had told him, either his mother or his mother-in-law was born the daughter of a plantation owner. Since she had been seen treating her half brother as her brother in public, she had been arrested and convicted for "consorting with a black man." According to the law, they did not see him as her brother and claimed they were a couple. Under the segregation laws in Mississippi at the time, a white woman seen or known to associate with black men was considered off-limits, despite how the plantation owners themselves would often brag about their black mistresses to their buddies.

The moral attitude of the time, especially among rich white girls, all debutantes of southern society, would not have led such girls to so flagrantly chase after the *white* boys at the school, much less the lone young black man enrolled at the school, unless it was a setup. It was thought highly improper for any girls of class to chase after boys in the early 1960s. This had to figure into Mr. Meredith's thinking when he heard McDowell say how all the white girls chased him and how he feared reprisal from the white boys at the school.

U.S. marshals stayed with Mr. Meredith while he was a student, so his educational experience as related in the book was different. He had some students who would attempt to be friendly with him, but other students who opposed his being there would scare away those who meant well. Mr. Meredith's maturity and his ability to talk his way out of trouble, in conjunction with having U.S. marshals guarding him, could be why he had such a different experience.

Cleveland McDowell could have been one of those young people who needed Dr. King's celebrity as a cover to force change. Any of the young African Americans at the time could have been so caught up in the riot that they saw Guihard as a voice of the oppressive White Council, or one of Bowers's White Knights of the Ku Klux Klan could have seen Guihard at the White Council rally and then again on campus. The code of silence was very strict, and their hatred of outside influence (especially those trying to interfere with their own little private kingdom where they were

allowed to treat anyone they wanted as slaves) could have been the reason Guihard was killed.

Bowers's own reasoning behind the Freedom Summer Murders in 1963 could have also factored into why Paul Guihard was murdered. Bowers and his group had killed countless black men in Mississippi and brushed this off. Bowers wanted the kind of attention the Ole Miss Riot received, as well as wanted to get the upper hand of power back that his white segregationists lost when Mr. Meredith was allowed to enroll at Ole Miss. Murdering a journalist from a major foreign newspaper could have been the first step he needed to begin the race war that he hoped to create.

EDWARD L. CATES

When researching hate crimes, particularly those connected with the civil rights era, finding one murder inevitably leads to more. Such is the case with Edward L. Cates, former Mississippi state deputy attorney general, former advisor to segregationist Mississippi governor Ross Barnett and one of the men who persecuted James Meredith in his quest to attend Ole Miss. Cates sat second chair to the State Attorney General Dugas Shands during the trial.

In his book *James Meredith vs Ole Miss*, Mr. Meredith revealed that Cates was a close friend and advisor to Governor Barnett and came up with the idea to arrest Mr. Meredith and the U.S. marshals protecting him. Some estimates say that up to five hundred marshals were protecting Mr. Meredith. The plan was to arrest them and make them disappear, eerily foreshadowing the events that would befall Schwerner, Haney and Goodman the following year during the Freedom Summer, committed by Edgar Ray Killen and orchestrated by Samuel Bowers.

Mr. Meredith noted that when they were in southern Mississippi in the first trial, Cates convinced the judge that they only needed a twenty-minute break for lunch, knowing full well that the area of the town known as "Black Town" was too far away for Mr. Meredith and his legal team to enjoy a good meal and recover for the next round of the trial. Cates quipped that there were plenty of places around the court square to eat, knowing that the all-black legal team and Mr. Meredith were legally forbidden under state law to enter these places to eat—in response to the lawyers' complaints about such, they were met with the decision of twenty minutes. They were forced to enter the alley behind the cafés and request

bag lunches at the back door. Not only was this humiliating, but there was also the potential that Cates and Shands could get into the kitchen to interfere with the health and safety of the food.

Years after Mr. Meredith graduated Ole Miss, but before he served in the United States Congress and in cabinet positions with President Reagan, Cates was accused of embezzling from one of his clients. A June 1983 edition of the *Chicago Tribune* states that it was only $200,000 that Cates stole, while the *New York Times* lists the number as $223,000; a different news source, identified as UPL, reports that the number was even higher, totaling $233,000. Cates's activities were odd. He would buy Cadillacs in New Orleans and sell them in Jackson for half the buying price. He looked to be attempting to pocket quick cash. He would also buy several life insurance policies. Perhaps knowing that his time was drawing near and that his dirty deeds would soon be discovered, he made arrangements to fake his death.

He told his family that he was meeting a potential client for dinner. This man is believed to be the unidentified man who was found in the remains of Cates's burnt-out car on May 13, 1983. It was reported by the *Chicago Tribune* that the body of the man was so badly burned, the only way to make an identification was by the remains of a partially burned shoe that was said to have belonged to Cates.

Cates's wife and twenty-year-old daughter had no idea that he could be facing criminal charges. They buried the body within three days of recovering it. Three days does not seem like a very long time to discover the cause or reasons behind the mysterious alleged death of Cates. As a known public figure for more than twenty years, it seems that the authorities would have gone to great lengths to discover the how and why surrounded his death.

Cates, though, fled to Georgia, and despite his attempts to escape his crimes, he could not relinquish ties to his family. He would send a telegram less than a month later to his wife, expressing his condolences on the death of her husband. He would then later send $4,000 in money orders to his wife.

Cates assumed the identity of retired brigadier general Christopher Curts and referred to Cates as "Chic" in these pieces of correspondence. Cates's wife was unfamiliar with this nickname and was also unaware of any known acquaintances of her husband who went by this name. Believing that her husband was murdered, Cates's wife refused to cash the money orders until she had more information. Once she learned that this mysterious General Curts had been deceased for some time, she informed authorities. It can only be assumed that due to the suspicious circumstances surrounding her husband's death, she may have believed that perhaps this

was the killer attempting to either play mind games with her or express remorse for the death of Cates.

Acting on a hunch, a Jackson city police officer and a Madison County sheriff's deputy who knew Cates well and had worked with him in the past were sent to Georgia to investigate the source of these mysterious money orders. Upon arrival at the given address in Lawrenceville, Georgia, they knocked on the door, and the mystery man was no longer a mystery. While in Georgia, the State of Mississippi ordered that Cates's grave be exhumed.

Cates himself answered the door and responded to the officers, who referred to him as Mr. Cates during the arrest. Knowing that his time on the run was up, Cates went with them without incident. Cates would be found guilty of murder and arson in Madison County, Mississippi, and embezzlement in Hinds County, Mississippi. He pled guilty in Madison County on the charges of murder and arson. He apologized to the court, his family and to the law profession. He expressed no remorse for the victim, nor did he identify the victim.

The body of the victim was sent to Florida to allow an allegedly unbiased forensic pathologist to perform an autopsy. The pathologist revealed that it was a white male between thirty-five and fifty-five years old. An article published by UPI in January 1984 reveals that further investigation into the identity of the man found in the remains of Cates's car was unsuccessful.

Given the known secretive racist history of the state of Mississippi and Cates's own involvement with the White Council in the 1960s, had the autopsy been done in state, it would have been challenged in the court of public opinion—perhaps since the man Cates had attempted to keep out of Ole Miss was now a Columbia University–educated attorney and politician.

Cates's involvement in the integration of Ole Miss, his friendship and advisory role to Governor Barnett, his own political career and the murder trial ensured that the eyes of the nation, if not the world, were on Cates during the trial.

A former newspaper editor wrote on her blog in 2009 that Cates "died again," this time for real, while incarcerated at Parchman State Penitentiary. A friend of the editor's, Bill Sumrall, revealed to her that this real-life case inspired another of John Grisham's bestsellers, the novel *The Partner*. The editor then noted that in all the time Cates had been in jail, he never revealed a name or any identifiable information concerning the man he killed to act as a body double. The blog post was written shortly after Cates's death in 2009, and now it can be assumed that the identity of the man in question

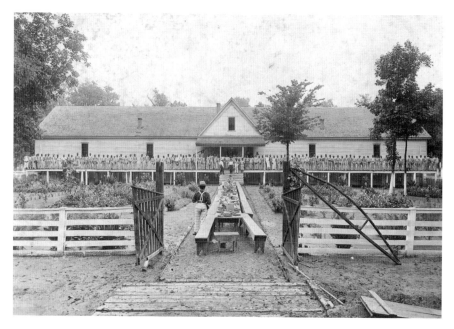

Parchman Farm, founded in 1901, housed both Sam Bowers and Edward L. Cates until their deaths. *Mississippi Department of Archives and History on Flickr.*

died with Cates. As of the blog post's writing, authorities were no closer to determining an identity.

A homeless man or transient could go for months without being reported missing, and since the body was heavily burned, the features of the victim as well as any potential DNA evidence were destroyed in the fire and are unrecoverable, even with modern technology. It is likely that the victim had originally been from another state and was listed as missing there.

However, some transients are never reported as missing because their families never report them or are used to their wanderlust (and the family member usually shows up days or weeks after the initial disappearance). For the family of Fernis Leblanc, who was a victim of the mass murder that occurred at the UpStairs Lounge in June 1973, his family did not know what happened to him for decades. It was almost forty years before his nephew discovered his name listed among victims who had died in the fire that swept through the UpStairs Lounge like a raging wind.

This gives a possible glimmer of hope for this nameless victim of Cates's unrepentant violence—perhaps one day, as science advances, he may be identified and returned to a family who may still be wondering what happened to him.

SERIAL KILLERS

T he public has a morbid fascination with the mythos of the serial killer. Shows like *Criminal Minds* touch on the mythos, sometimes including factual information from some of history's most notorious serial killers. The show, however, fails on one account: it makes the characters of the Behavioral Analysis Unit seem almost superhuman, thus giving the audience unreasonable expectations about the abilities of law enforcement—a phenomenon my former criminal justice advisor and retired Louisiana state trooper William Lopez referred to as the "*CSI* effect." Just how did this phenomenon begin?

As the National Institute of Justice (NIJ) notes, "Many attorneys, judges, and journalists have claimed that watching television programs like *CSI* has caused jurors to wrongfully acquit guilty defendants when no scientific evidence has been presented. The mass media quickly picked up on these complaints. This so-called effect was promptly dubbed the '*CSI* effect,' laying much of the blame on the popular television series and its progeny."

Unfortunately, while it makes the public more aware that we live in an imperfect world where evil people exist, it seems to also incorrectly inform them about what police can do and what tools are available to them. The NIJ pointed out that one juror's reasoning behind the vote he cast was because the police did not "dust the lawn for fingerprints." If forensic techs can dust grass for fingerprints, I must have missed that lesson in four years of college and a year of graduate study.

The ability to track and solve an entire crime within the space of each show is a common trope for many of the most popular crime shows. Shows like *Criminal Minds* and the "based on reality" shows like *Law and Order* often promote the misconception that serial killers can be captured in the span of a one-hour-long episode.

Criminal Minds does give the impression that the analysts are invited in once the police have exhausted most resources and request the help of the FBI (usually when it comes to major arcs of the show, such as the one case of a serial killer from Boston, played by C. Thomas Howell, who eluded the team for most of a season). This is similar to real-life serial killer BTK, who took an even larger break than normal for a serial killer's cooling-off period.

So, with shows such as these so popular and long-running, the question remains: are serial killers that common?

According to Supervisory Special Agent Robert J. Morton of the FBI's Behavioral Analysis Unit, the lead contributor to an article posted on FBI.gov, "Serial murder is a relatively rare event, estimated to comprise less than one percent of all murders committed in any given year."

Furthermore, he wrote, "There has been at least one attempt to formalize a definition of serial murder through legislation. In 1998, a federal law was passed by the United States Congress, titled: Protection of Children from Sexual Predator Act of 1998 (Title 18, United States Code, Chapter 51, and Section 1111). This law includes a definition of serial killings: The term 'serial killings' means a series of three or more killings, not less than one of which was committed within the United States, having common characteristics such as to suggest the reasonable possibility that the crimes were committed by the same actor or actors."

The report SSA Morton and others wrote only discussed research on serial killers in the nineteenth century. They mention Jack the Ripper in London and Dr. Richard von Krafft-Ebing, who conducted research on sexual deviants in mainland Europe. In determining the definition of serial killers and what exactly made murderers serial killers, they do not mention the man previously claimed as America's first serial killer, John Wesley Hardin. Hardin was a gunslinger in the Old West, but he does not fit the definition presented by the FBI. Hardin was an indiscriminate killer.

Mississippi has the distinction of being home to not merely the first serial killer in the history of the fledgling United States but the first *three* serial killers in the United States. Perhaps not so surprisingly, each of these three men had previously held positions of great respect within their communities. The first two, cousins who went by the moniker of the Harpe Brothers, had

previously fought for the Tories during the American Revolution. The other, Samuel Mason, who would become an ally of theirs, had once been a judge.

They would spend years as allies, but one of the Harpe Brothers would get greedy. For lack of another victim, he tried to lay claim to being a decent human being who was attempting to do a public service by taking law enforcement up on their offer of a reward for the capture or proof of the death of Samuel Mason. This is not unusual in the world of serial killers. Several decades later, in the investigation of Gary Ridgway (the Green River Killer), some of the murders were originally attributed to Ted Bundy. In the manhunt for the Green River Killer, a detective named Dave Reichert took Ted Bundy up on his offer to help get inside the mind of the Green River Killer. Bundy was a native of Tacoma, Washington, which was close to the Green River. Bundy, who had been convicted of his own series of crimes and incarcerated in Florida, wrote to Reichert and offered his expertise on serial killers. At the time of his letter, the Green River Killer had claimed the lives of forty-eight people, and five have been dumped in or around the Green River.

According to a *New York Times* article, Reichert flew to Florida with another investigator to study what makes the mind of a serial killer work. Despite Ted Bundy's offer to help in 1986, it took twenty-one years to capture Gary Ridgeway. It was not until 2003 that Gary Ridgeway pled guilty to being the Green River Killer.

When it comes to serial killers, Mississippi has had more than its fair share. In addition to the three who hunted in the aftermath of the American Revolution, there were at least four serial killers who prowled the darkness of Mississippi. The Harpe Brothers and Samuel Mason hunted the area that is now known as the Natchez Trace Parkway in the late 1700s, the Truck Stop Killer lurked in the shadows between 1975 and 1990, the Red Head Murderer was active from 1978 to 1992, the Cross Country Killer was active between 1993 and 1995 (and claimed to be the actual hands-on killer of Nicole Brown Simpson and Ron Goldman) and the Ghosts of Mississippi Killer was active from 1996 to 1998. The brief duration of the Ghosts of Mississippi Killer's run led to questions about why he was dormant so long before he was captured, but Dennis Rader (BTK) had a cooling-off period of more than twenty years. It is not unheard of that a known serial killer would lie dormant for so long while remaining alive and not in jail.

The FBI's symposium on serial killers discussed how rare were the serial killers who came through Mississippi. They dismantle the myth that serial killers are itinerant loners:

Most serial killers have very defined geographic areas of operation. They conduct their killings within comfort zones that are often defined by an anchor point (e.g. place of residence, employment, or residence of a relative). Serial murderers will, at times, spiral their activities outside of their comfort zone, when their confidence has grown through experience or to avoid detection. Very few serial murderers travel interstate to kill.

The few serial killers who do travel interstate to kill fall into a few categories:

- *Itinerant individuals who move from place to place*
- *Homeless individuals who are transients*
- *Individuals whose employment lends itself to interstate or transnational travel, such as truck drivers or those in military service*

The difference between these types of offenders and other serial murderers is the nature of their traveling lifestyle, which provides them with many zones of comfort in which to operate.

As this chapter will discuss, Robert Ben Rhoades and Glen Rogers are two perfect examples of what the FBI describes as iterant serial killers. The FBI report also disposes of the myth that all serial killers are sexually motivated. Rhoades was sexually motivated, but Rogers was not necessarily. As for David Murray, who is currently on trial for the murder of one of the victims associated with the Ghosts of Columbus serial killings, he lived within the same three miles of the victims and the man who is suspected of being the Mississippi Vampire Rapist; five of the victims were disposed of within only a few miles of the man's home.

While the Vampire Rapist and Rhoades were motivated by sexual torture, as the FBI wrote, "All serial murders are not sexually-based. There are many other motivations for serial murders including anger, thrill, financial gain, and attention seeking." However, anger was a key element in the sexual torture that Rhoades and the alleged vampire visited on their victims. Rogers's reasoning behind the crime (for which DNA conclusively connects him to the murder) included rage and financial gain.

As for the Red Head Murderer, the crimes associated with this killer are believed to have occurred during the time when Rhoades and Rogers were committing their crimes—oddly enough, they stopped once the two were sentenced for other crimes. Rhoades was investigated for these crimes since some of the victims were sexually assaulted. Some of the victims were not

sexually assaulted. These crimes are still classified as open, as are many of the Ghosts of Columbus killings. Due to the varied manner of the deaths of the five elderly victims, an officer who had been on the force for some time before these murders (and is still on the job) now believes that not all the killings were committed by the same person. As two men have been arrested in connection to these killings, the various manners of death for the victims could very well have been accomplished by others.

THE HARPE BROTHERS

In the aftermath of the American Revolutionary War, there was not one but three active serial killers in Mississippi. Two were a team: the Harpe Brothers—Micajah "Big Harpe" Harpe and his cousin, Wiley "Little Harpe" Harpe. They were aligned with the British during America's war for independence, odd considering the cousins were originally from Scotland and had their own share of problems with the imperial rule of England. They were more marauders than actual soldiers. They used the opportunity provided in the chaos of war to rob people, rape women and generally make life miserable for the Patriots. Most accounts of the Harpe Brothers have them listed as war criminals by both sides in the war since they are believed to have joined a Tory rape gang in an attempt to sate their savage bloodlust.

There are different accounts of just how many women they kidnapped, tortured and claimed as wives. Some accounts say three and others just two. One of the women was Susan Wood, the daughter of Captain Frank Wood, who had previously attempted to stop the Harpe Brothers some twelve years before Susan's kidnapping. Captain Wood succeeded in saving a girl's life, wounding Wiley in the process. The Harpe Brothers took revenge when they kidnapped Susan and forced her into a life of servitude.

There is no way to accurately determine just how many Patriots were murdered by the Harpe Brothers due to the tragedies of war. No one seemed to attribute any of the deaths to the Harpe Brothers specifically, as they were a part of a Tory rape gang during the war.

Sometime between 1794 and 1797, the Harpe Brothers began to walk their trail of death. It is noted that in 1797, the Harpe Brothers were forced out of the Chattanooga, Tennessee area for killing a man and stuffing his chest full of stones before dumping his body in the river. This was the murder that would mark their escalation into the definition of serial killers.

The Harpes were soldiers in the Revolutionary War, fighting on the side of the British. *Wikimedia Commons.*

Filling the chest full of stones would become the signature of their murders. They were chased and caught for this crime and several others but managed to escape from jail. When they learned that it was an innkeeper who had turned them in, they sought revenge by murdering the innkeeper's son on their way out of town. This brought the known body count as of 1797 to two—not quite enough to declare them serial killers.

The Harpe Brothers achieved the status of serial killers while on the run north to avoid recapture. Before they joined up with Samuel Mason and his band of pirates at the Cave of the Rock in Illinois, they had killed five more men. The Harpe Brothers would not stay long with the ruthless band of pirates. Mason asked them to leave after several of his captives (whom he hoped to ransom) were murdered by the Harpe Brothers simply for the love of killing. But the Harpe Brothers did not simply kill them. They made them strip naked and intimidated them until they fell off the cliff overlooking the cave that the Mason pirates used as a hideout.

There is no accurate number of how many of the captives were killed by the Harpe Brothers, but once they were forced out by the pirates, the recorded murders attributed to them jumped from five to thirteen. One in 1798 is said to have been the infant daughter of Big Harpe, who was

annoyed by the constant crying. He is later recorded as saying that this was the only murder he regretted, despite the legends that told how the Harpe Brothers had children with their wives and other kidnapped women and then murdered them. They inflicted torture on Susan Wood and fellow captive Maria Davidson in order to get them to stay, even when the two were in jail, perhaps the first case of what would be come to be known as "Stockholm syndrome." Killing their children would also have been a demoralizing way to gain control over the women, especially Wood, who had a father who could and would have protected both women if they had been able or inclined to escape after the atrocities they experienced.

An additional four murders were committed after Big Harpe killed his own child. The Stegall family gave them shelter for the night, not knowing what monsters they harbored. When another guest appeared at the house, a soldier named Major William Love, they decided to kill him in the middle of the night. The Stegalls' four-month-old child woke up and began crying. Big Harpe, having no patience for crying children, killed the infant. When

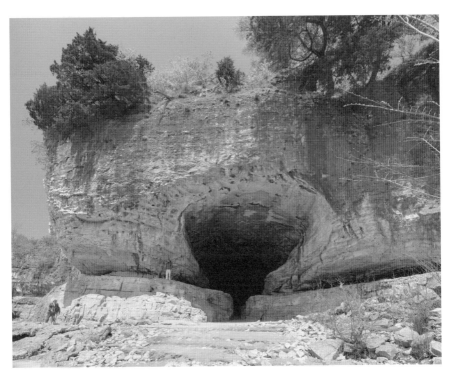

The Mason hideout known as Cave in the Rock. *Daniel Schwen, via Wikimedia Commons.*

Mrs. Stegall came to care for her crying child, she screamed in horror. Her outburst caused her to be silenced forever.

When the Harpe Brothers fled to the Natchez Trace area, they mocked the local stories about the Witch Dance. They visited the spot where the alleged witches danced and killed the grass. Big Harpe is said to have danced, stomped and generally mocked the areas where the grass had withered and died. He would call out to the witches and taunt them to show themselves. Ironically, this seemed to seal his fate.

Within weeks of Big Harpe mocking the witches, a posse had formed after the murders at the Stegall homestead—and Big Harpe would be decapitated. John Leiper may have been the man in charge of the posse, but the heart of the posse had to be Moses Stegall, whose wife and child had been murdered by the Harpe Brothers. Leiper's posse found the brothers in August 1799. They attempted to flee when Leiper demanded they surrender. Big Harpe was shot and pulled down from his horse by Leiper. As he died, he seemed to scoff at Leiper and confess to twenty murders. After he made this confession, Moses Stegall cut off his head while Harpe was still conscious. He would later bring the head back to his home and place it on a spike. From an article published by the *Vintage Press* in March 2017, the road closest to the location where the head rested on its spike is believed to still be called Harpe's Head Road. Mere minutes from the Natchez Trace Parkway in the area now known as Blue Springs, Mississippi, there is a street known as Little Harpe Trail.

Author's photo.

SAMUEL "WOLFMAN" MASON

Some legends attribute Samuel Mason as the leader of a pirate gang, others a highway man who robbed people in the Natchez Trace area. In some sources, he is listed as the "Natchez Trace Killer." In the research for the Harpe Brothers, the legends tell two stories. One is the story told in the Harpe Brothers' tale about a bloodthirsty, marauding pirate holed up in a cave in Illinois. The other tells about a patriotic American who served his fledgling country well.

After Big Harpe was killed, Wiley "Little Harpe" made his way back to Cave in the Rock to join up with the Mason Gang. Mississippi governor William C.C. Claiborne ordered Colonel Daniel Burnett to track down Mason and his men. He authorized a reward of $2,000 for their capture. Despite the countless number of people searching for the Mason Gang, they continued their murderous spree. No matter how close they got to the known whereabouts of the gang, no one could kill or capture them. They found a camp, and many of the posse dropped out of the search in fear since the

The historic Natchez Trace trail where Mason committed a series of robberies and murders was also the hunting ground of the notorious Harpe Brothers. *Wikimedia Commons.*

The skull and crossbones pirate flag looks even more sinister in conjunction with the history of Samuel "Wolfman" Mason, notorious land pirate and serial killer. *Wikimedia Commons.*

campfire was still smoking from being doused, perhaps within minutes of the posse's arrival. They chose to search the camp for abandoned loot rather than continuing in an attempt to bring the culprits to justice. A handful of men still pursued the pirates but quickly lost the trail and their interest in pursuing the bandits.

However, when Governor Claiborne increased the bounty on Mason an additional $500, Wiley Harpe quickly realized that $2,500 was too much money to pass up. He would add Samuel "Wolfman" Mason to his list of victims.

In September 1803, Wiley and an accomplice pounced on the wounded pirate captain. They cut off his head and brought it to town in an attempt to collect the $2,500. Being a notorious criminal himself, Wiley was quickly recognized. He and his accomplice were arrested and tried in federal court for piracy.

They were found guilty and sentenced to death. They were hanged in Greenville, Mississippi, in early 1804. The legend of the American pirate Samuel "Wolfman" Mason lives on to the modern age. Cave in the Rock is now part of an Illinois state park. It is believed that at the fifty-five-foot-wide

cave, more than $1 million of stolen goods exchanged hands in forty years. There is a rumor that somewhere within there was a large stash of gold buried here, but Wiley Harpe murdered Mason before it could be recovered. It has given rise to the ghost story that Samuel Mason still roams the cave in search of the loot he was never able to recover in life.

THE TRUCK STOP KILLER

Robert Ben Rhoades (known as the Truck Stop Killer) is the man convicted of three murders connected with the murders and sexual assaults of teenage runaways from a period between 1975 and 1995. Rhoades was born on November 22, 1945. He only admitted to the three murders. These are the only three murders for which he was subject to prosecution either because of lack of evidence or because of the family's choice not to prosecute.

In 1994, Rhoades was convicted of first-degree murder of Regina Kay Walters and sentenced to life without parole in Illinois. He was extradited to Utah to face prosecution for the murders of Candace Walsh-Zyskowski and her husband, Douglas Zyskowski. Candace spent more than a week as a victim of Rhoades's sexual sadism before her tragic death. Candace's body would not be identified until 1992. The body was dumped in Millard County, Utah. The families originally asked for the charges to be dropped, and he was returned to prison in 2006.

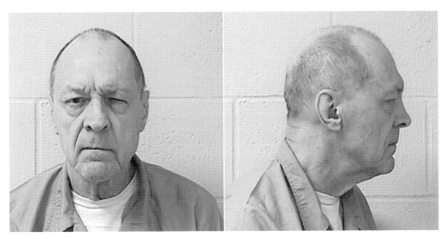

Robert Ben Rhoades's mug shot. Rhoades's job as a truck driver allowed him to kill across the country. *Illinois Department of Corrections.*

Rhoades would later be transferred to Texas, a death penalty state, since it was in Sutton County, Texas, where Rhoades had dumped Candace's body. In order to avoid the electric chair, Rhoades pleaded guilty to both of their murders and received two additional life sentences.

Two other murders allegedly were scheduled to be prosecuted in relation to the Truck Stop Killer, but the family urged the prosecutors to drop the case. He was already serving three life sentences without the possibility for parole and was already in his fifties. There was no hope of his ever being released. A trial would and could last for several years. The families would be forced to sit and listen to the depraved details of the trauma their loved ones suffered before they died. Perhaps his three prior sentences allowed them enough closure to move on and grieve in private.

Even though Rhoades only admitted to and was convicted of three murders, law enforcement officials believe the number to be at least fifty, if not more. Police estimate that between 1975 and 1990, Rhoades tortured, raped and killed more than fifty victims. However, since he crisscrossed the country, bodies were left in remote locations in several states, and some still have not been found.

One of the most unnerving things about Rhoades is an infamous picture of Regina Kay Walters looking terrified in a black dress and heels that he took shortly before killing her in an abandoned barn in Illinois. Rhoades's most macabre claim to fame is his mobile torture chamber. He had converted the sleeper cabin of his truck into a soundproof dungeon complete with eye bolts screwed into the walls on which to attach his shackled victims.

Initially, it was believed that his first attack came in November 1989. The first victim only accused him of rape, kidnapping and torture but would later recant when faced with identifying him in court. Officials believe that after being held captive for at least two weeks being raped and tortured she was simply too scared. As a teenage runaway and a victim of torture, she was perhaps afraid that it was her word against that of an adult with a respectable job that conditioned her into remaining silent.

The Zyskowskis were the first identified victims of the Truck Stop Killer. He picked them up in January 1990. In an act of control and intimidation, he killed the husband first, as he was the biggest impediment to what he desperately craved: sexual sadism.

One month after Candace Walsh-Zyskowski was killed, Texas runaways Regina Kay Walters (fourteen years old) and her much older boyfriend,

Ricky Lee Jones, disappeared. As he had done previously with the older couple, he killed Jones almost immediately and dumped his body in Lamar County, Mississippi. His remains would not be identified until July 2008. The much younger girl was easier to control than the older runaways he had taken. He was able to use psychological torture to keep her in line enough that a witness claims that while under Rhoades's control she was seen alone standing outside the truck in Chicago perhaps mere hours before she was murdered.

Arizona Highway Patrol officer Mike Miller is believed to be the officer who first realized what kind of threat Rhoades was, or perhaps it was his instincts as an officer that made him want to inspect a tractor trailer pulled off on the shoulder of the road with its hazard lights on. Inside, he found a screaming woman shackled to a wall, nude, with a man who would identify himself as the owner of the truck and claim that the S&M going on within the cabin was consensual. The officer reported that Rhoades attempted to talk his way out of the situation, but lacking the charisma of a serial killer like Bundy, he failed to convince the officer to leave. He arrested Rhoades on sexual assault, unlawful imprisonment and aggravated assault.

The woman, later identified as Lisa Pennal, suffered from what sounds like schizophrenia—she believed that people were attempting to hijack her brain. Considering the type of psychological torture that Rhoades liked to inflict, any progress Pennal's mental health professional had made with her likely suffered an unfixable setback. Since Pennal would not be considered a reliable witness because of her mental illness, combined with the psychological trauma she had endured with Rhoades, officers used her case as probable cause to investigate him further. It allowed officers to get a search warrant for Rhoades's home in Texas, as well as his truck.

For the families of Walters and Jones, this could only be a glimmer of hope. A search of Rhoades's residence revealed countless pictures of what officers could only suspect were other victims of his depravity. Among these items were images of Candace Walsh-Zyskowski and nude images of Regina Kay Walters.

In 2012, reporter Vanessa Veselka wrote an article for *GQ* about her experiences as a teenage runaway and hitchhiker during what her article seems to allege was the height of Rhoades's spree. Her take on the case was that the truck driver was preying on victims he believed would not be missed, namely runaways. Veselka admitted to being one of these errant

rebellious girls. She recalled how she ran away in 1985 and saw a body being pulled from a dumpster. She believed it was in Pennsylvania.

Veselka noted that a witness reported that it was a teenage hitchhiker and admitted that a slight tremor of fear went through her since she *was* a teenage hitchhiker. She recalled one of her drivers who was in a hurry to leave, and neither discussed the dead girl. This driver was good to her and did not mistreat her in anyway. He even made a point to make sure she had a decent meal without expecting her to reciprocate in any way. Veselka was quick to point out that in her experience, a trucker like this was extremely rare. To contrast the difference between truckers, the next driver she mentioned kept a meticulously clean truck, as opposed to the previous driver, whose truck look "lived in," as he spent a lot of time on the road (reasonable for a long-haul trucker). While she found the cleanliness of the truck odd, she assumed he was initially okay, as she never would have accepted a ride with this man otherwise.

Veselka noted that it was not long after he began driving that she knew he was going to be one of the inappropriate ones who either tried to rob her or molest her. Veselka's first impression was wrong and her second, while closer to the mark, was straight from her nightmares. He was more than inappropriate—he was downright weird. Veselka alleged that he soon began making jokes about the dead girl in the dumpster and claimed that he was a member of a secret group that laughed at death.

It was not long after the morbid jokes about the dead girl that he pulled off on the side of the road and brandished a knife. He attempted to force her into the back of his truck, but Veselka began to attempt to talk her way out of it. She swore to him that if he let her go, she would not tell anyone or go to the police. Veselka reported that he told her to get out of the truck and run as if he was going to attempt to hunt her in the woods that bordered the road. She ran, breathing into her shirt to muffle the sound, and then hid so she could check to see if he was chasing her. He wasn't. She stayed in the woods and watched as he left. Veselka, it seems, had learned quite a bit of street smarts from her time on the road, as she stayed hidden until it began to grow dark to ensure that he did not come back for her or double around to catch her from behind. She eventually left her hiding spot and caught a ride with another driver to put distance between herself and the other man. Veselka reported that it was years before she told anyone what had happened to her.

Veselka noted that the reason she chose to write the piece in 2012 was because earlier that year, a friend that she had confided in sent her a link to

an article concerning a man named "Robert Ben Rhoades" and asked if this could have been the man who attempted to attack her. Veselka admitted that the picture of Rhoades was of an older man, and her memory after such a long time could have been unreliable.

She was not sure that he was the one until she began to research Rhoades's case and the connection to the moniker the "Truck Stop Killer." When she saw younger pictures of him, she began to get curious about this driver who had picked her up and attempted to assault her. She stated that she originally called the FBI to claim that she may have been a near victim of the man the press called the "Truck Stop Killer" but admitted that she was relieved that no one from the FBI returned her call. She noted that her memory "after twenty-seven years was hazy"—due both to time and the state of fear in which her memories were formed.

For the purpose of her article, Veselka investigated the mysterious life that Rhoades led in the 1980s. She interviewed law enforcement involved with the case as well as Rhoades's ex-wife, Debra. Veselka discovered that Rhoades was a BDSM swinger and noted that when captured, he stated that "he had been doing this for fifteen years." Was this an admission of guilt or confusion? Was he delusional enough to believe that the women he assaulted were willing participants in his machinations? Then why kill them? Did he have a moment of clarity in which he was ashamed of his actions?

Veselka did not seem to know either but erred on the side of believing that he was admitting he had been sexually assaulting and murdering people since the mid-1970s, which would certainly have made it possible that her would-be attacker was Rhoades. Veselka's investigation revealed that the logbook that all truckers are required to maintain placed him in the vicinity of at least fifty unsolved murders just in the three years prior to his arrest.

Veselka reiterated that Rhoades only admitted to the three murders for which he had already been convicted and pled both innocence and ignorance of the others. Veselka cited that her friend was adamant that Rhoades was the one Veselka had interacted with and incorrectly assumed that Rhoades was a singular oddity. Through crime reports, Veselka would soon discover more than five hundred bodies, mostly women, and of the two hundred people of interest on law enforcement suspect list, many were long-haul truckers.

Veselka revealed in her article that during the time when she was a teenage hitchhiker, people did not distinguish between prostitutes and

hitchhikers. The rampant misogyny of the era was disgusting, and it was not just the way of the truckers. Veselka could not even attempt to hitch a ride with a traveling family in a station wagon. Waitresses in truck stops would be the first to force unaccompanied young women out of the restaurant. Veselka admitted that she would have to beg for rides in the hallways near the truck stop showers. She also stated that this was how she was treated. She revealed the sad fact that in the event a hitchhiker or prostitute went missing, it could be months before a report was filed. Forensic evidence would have all but disappeared in this time. Veselka concurred with this, as she stated that "the diminishing amount of evidence between the actual time of a disappearance, the time a report is filed, and the appearance of a body most likely in a different state" makes it nearly impossible to catch a killer who preys on this demographic. Veselka then revealed a startling fact: when officers put out a physical description of Regina Kay Walters, they received a response of more than nine hundred potential bodies that were in various morgues.

Upon learning this, Veselka expressed her remorse that she failed to report her own encounter with a violent trucker because of all the murders that Rhoades is believed to have committed. Had she reported her own experience, law enforcement may have been made aware even earlier of the potential danger to teenage hitchhikers. Veselka interviewed Robert Lee, a retired FBI agent who worked the case of the Truck Stop Killer. Lee told her that she couldn't blame herself. She did not commit these horrific acts. Rhoads was the one solely responsible for his own actions.

Veselka admitted that she was afraid when she reported the incident, worried that no one would have believed her and that it would have been a case of her word versus the trucker's. Agent Lee confirmed that this was the belief of several of the girls allegedly assaulted by Rhoades. He admitted that Pennal would likely not have been a reliable witness due to her mental health issues.

In Veselka's article, Agent Lee noted that another victim, Shana Holts, also believed it would be her word versus her attacker's. Lee believed that her attacker was Rhoades. Holts was found running down a Houston street, naked, covered in DNA, and her whole body was shaved. She still had the manacle and chain around her neck. The hair shaving was a signature of Rhoades's and had been something that law enforcement had noted during the investigation of Regina Kay Walters, who had also suffered this indignity.

Veselka discussed her own experience with Lee, and he coached her on how to write to Rhoades to discover if he was the one who had attempted

to assault her. Lee advised her to play to Rhoades's ego that he is an expert at murder and abduction. Perhaps he was, considering he did elude capture for more than two decades.

Veselka revealed that in a letter Rhoades wrote to her in response, he declared that he was not the one who attempted to attack her—considering he only admitted to the crime that he had been convicted of, this is not surprising. There is no statute on murder, and while Veselka was not killed then, had Rhoades admitted to this, it would refocus the spotlight on the crimes that he had committed. Rhoades would ultimately agree to be her expert into the mind of a sexual sadist, but he wanted her to pay him $500 for his service, plus he wanted her to speak with him in person—like a killer craving a fix by looking at souvenirs of his past crimes.

During Veselka's interview with Rhoades's ex-wife, Debra, she discovered frightening similarities with her own experience to the way Rhoades lived his life. When telling her situation to the former Mrs. Rhoades about the secret death society, Mrs. Rhoades admitted to Rhoades's obsession with secret societies, manipulative games and the sexual sadist couple who forced their victim to live in a box under their bed for years. Was this all a part of some sick game that Rhoades was attempting to play with Veselka both as a member of the media and a potential victim?

Two other serial killers were active prior to the capture of Rhoades in 1994. Glen Edward Rogers is believed to have started his killing spree in 1993, preferring redheads. Eerily, the Red Head Murderer, who has yet to be identified, is believed to have begun killing in 1978. Since he has never been identified, could he have also been a long-haul trucker? This would make it likely that perhaps he had been the one who had attacked Shana Holts in Houston.

If Rhoades is only suspected of fifty or so murders, the alleged numbers thus far, the suspected numbers in the Red Head Murders are between six and eleven between 1978 and 1992. Rogers himself is believed to be responsible for at least four murders. Who exactly is responsible for the remainder of at least five hundred victims with the same similarities? Granted, Rogers preyed on redheads and some of those later victims could be attributed to him, but could the early victims be attributed to Rhoades?

THE RED HEAD MURDERS

Very little is known is known about the Red Head Murders since most of the victims linked together have yet to be identified. The police believe that these murders ended in 1995 after spanning nearly two decades. The location of where victims were found led investigators to believe that the killer was transient.

What type of transient killer, then, is the Red Head Murderer? Is he a polished sociopath adept at hiding his dark side like Ted Bundy? Or does he have a job that takes him across country like Robert Ben Rhoades (the Truck Stop Killer)? Or is he a shiftless, violent wanderer like Henry Lee Lucas or Glen Rogers (the Cross Country Killer)? It is important to note that at least one victim of Rhoades's and multiple victims of Rogers's were redheaded.

The unknown is often the scariest part when dealing with serial killers. The killings of women and girls with red hair allegedly ended in 1995 shortly after both Rhoades and Rogers had been captured and were put on trial for their crimes. Victims have been found in Arkansas, Mississippi, Tennessee, Ohio, West Virginia, Pennsylvania and Kentucky, with potentially other victims being found in other areas of the southeastern United States. Of the two serial killers known to have crossed this same area, and given the unsubstantiated boasts made by Rogers to his siblings and authorities at the time of his arrest, could he be the one? Rogers is originally from Kentucky and admitted that his first killing happened when he was thirteen. At least three of his victims were dumped in Kentucky in his family's original home.

Among the potential killers, one must realize that if the murders originated in the late 1970s, then Henry Lee Lucas; his partner, Ottis Toole; and Rhoades were actively killing during that time. However, Lucas was captured in 1983, thereby eliminating him as a suspect in the later killings. Since the killings ended in 1995 and both Rhoades and

An artist's rendering of one of the victims of the Red Head Murderer. *Wikimedia Commons.*

Rogers were in custody at the time, it is a mysterious coincidence that no more victims were attributed to the monster known as the Red Head Murderer after 1995. Rogers was arrested in 1995 after a high-speed car chase in Kentucky.

The documentary *My Brother the Serial Killer* listed many unsolved murders that police believe Rogers committed. Detective Chuck Lee of Mississippi believes that due to the short amount of time Rogers spent with each of his victims, there are probably plenty more victims than the ones he was convicted of having. Detective Lee does not believe the boastful number that Rogers claimed (seventy). Seven victims were connected to Rogers. Of the four women linked to him (two of whom he was convicted for killing), three had red hair. The sister and mother of Jackson, Mississippi murder victim Linda Price reported that Rogers picked up a lock of Price's red hair and made it a point to mention that he liked it.

Since Rogers is most notable for crimes committed in the 1990s, and because three of his victims shared the same hair color, Detective Lee concluded that Rogers was a serial killer. Detective Lee noted that his phone rang off the hook from other agencies about the possibility that Rogers could be responsible for their own unsolved crimes. Investigators from other states wanted to check into the possibility that Rogers was the killer.

It is believed that the first murder happened in 1978, and Rogers had a criminal record by this time. He was fifteen. Rogers admitted to being exhilarated at what he believes was his first murder in 1976. Rogers's own brother, Clay, believes that the lack of fear and affection for violence began much earlier. Transportation could have been a concern for a blossoming serial killer, but he admitted that the body of the woman that he shoved down the stairs was dead when his father finally made him come downstairs. His father also made him carry the body to the trunk of his car, and they disposed of her on the side of the road.

One of the key elements in the Red Head Murders is the fact that most victims were found on the side of major roadways. A Wikipedia search of unsolved murders lists other potential victims of girls and women with varying shades of red hair who were found alongside major highways, including a girl found in Ohio known as "Buckskin girl."

Michael Newton in his *Encyclopedia of Serial Killers* (2nd edition) explained why it possibly took so long to connect Rogers to his nomadic killings, as well as the reason very few were positively identified. Newton wrote that "nomadic killers are the travelers, moving frequently often compulsively from one location to another, killing as they go. Such hunters are the prime

beneficiaries of 'linkage blindness' drifting from one jurisdiction to another to another before police in one area recognize a pattern of behavior."

A popular theory on the Internet is the connection to Shana Holts in the Houston area. Holts is the woman who had been tortured and raped by Rhoades before being found shortly after her escape running nude along a Houston street. Holts's body had been shaved of all hair, and she had been sexually assaulted. She had initially identified Rhoades as her attacker, but she believed that when it went to court, it would be her word (a runaway teenager) against that of an adult with a full-time job.

To determine whether victims correspond to a particular serial killer (Rogers or Rhoades) or a potential unnamed perpetrator would have to go past the initial connection (the shared hair color) of the victims within the scope of the killers' signature. Most of the victims attributed to Rogers had red hair, but most were not raped. The sexual interactions with victims Linda Price and Andy Sutton were consensual and resulted from the fact that Rogers was in a relationship with the victims. Only Sandra Gallagher of California is believed to have been raped before Rogers killed her, setting her body and car on fire. This alone was a shift in his usual signature of stabbing.

Conversely, Rhoades was an admitted sexual sadist who delighted in the rape and torture of his victims before he killed them. He also shaved his female victims—one of the Red Head victims was cleanshaven, unlike many of the other victims. Another aspect of Rhoades's methodology was that he was not afraid to kidnap couples. In an act meant to intimidate his female victims, he would murder their male companion first, dump him in one state, sexually torture the female victim and then finally kill her in another state before moving on to another victim (or couple). Of the murders for which Rhoades was convicted, both women were traveling with male companions prior to their deaths.

In the Red Head Murders, one of the female victims was known to be traveling with a male companion. The initial investigation concluded that the woman may have been killed by her companion. However, the male was found dead in another state. The authorities then briefly investigated Rhoades in connection to the crime, but he was dismissed as a potential suspect.

An odd connection between the people listed as victims of the Red Head Murderer was the fact that one was pregnant and others had been mother to at least one child. So, redheaded murder victims, some sexually assaulted, some not, who were mothers or about to be mothers. Most were dumped along the side of major roadways near towns. Anthony Meoli, the profiler who interviewed

Rogers after his incarceration in Florida, believes that Rogers was killing women with red hair because his mother failed to protect him from an abusive father.

THE CROSS COUNTRY KILLER

Rogers is most commonly known as the "Cross Country Killer," and Paul John Knowles, while being noted as a "cross-country killer," is more commonly known as the "Casanova Killer." It is believed that Knowles traveled through Mississippi but is not known to have claimed a victim from the state or dumped one of his victim's bodies in the area. One of Knowles's victims was found in the two-thousand-mile Mississippi River, but the point of origin is unknown.

Glen Rogers believes that the reason he killed is because he was possessed by a demon and that the only way to purge himself would be his own death. His killer would then take the demon into themselves. This is why his own brother, Clay Rogers, believed that he would not be taken alive but rather would only be taken down in a shoot-out with law enforcement.

Glen Edward Rogers during his trial. *Wikimedia Commons.*

When questioned by police and in statements to his siblings, Clay and Sue, Glen claimed that the number of people he killed was more than the four or five to which he was linked and definitely more than the two for which he was sentenced to die. Since the redhead killings seem to originate in Kentucky—where at least three other victims were found in the dilapidated cabin that had been the first home that Rogers parents' had—could he really be responsible for more than seventy deaths? At one point, he told his brother he had killed fifty women, and later, while on the run for the crimes he is connected to, the offered number was closer to seventy. Seventy is the number that he mentioned to the Kentucky police after he was captured. He also told his siblings that not only had he known Nicole Brown Simpson prior to her death, he had also done work for her on her home. To his brother, he claimed to have went out with her on two occasions, and he even informed his brother that he had planned to rob and kill her.

With at least one victim of the Red Head Murders being killed in Kentucky and another in Mississippi, could these women be among the unidentified victims of Glen Rogers? At least some of the latter ones were committed in the 1990s when the crimes Rogers is known to have committed occurred.

In a documentary *My Brother the Serial Killer*, produced in association with Investigation Discovery, two of Glen Rogers's siblings—Clay and their oldest sister, Sue—were interviewed along with law enforcement and a Cincinnati-based reporter who were actively involved with the hunt for the man known as the Cross Country Killer. Sue was the oldest child, with Clay squarely in the middle, in addition to three older siblings and three younger siblings, including Glen.

Clay attributed some of the problems that inspired Glen Rogers to become a serial killer to the family's volatile, poor and violent upbringing. Clay claims to have seen evidence that Rogers had been sexually abused while in a reform school for juvenile offenders. Shortly after being released from this reform school, Rogers learned that a former girlfriend of his, Deborah Ann Nix, was in the hospital after giving birth. She was only fourteen years old, and the hospital did not want to release her since she had no home address or family who would claim her. Still claiming to have feelings for her, Rogers claimed the girl (affectionately called Debbie) and her child. The two quickly wed in 1980, and Rogers raised the child as his own. One year after they married, the couple had a child together. Clay believes that this was the one thing in his life his brother

wanted: a family, one that was of his own making and something positive to be proud of. Sue, however, stated that her baby brother abused his wife, often severely.

In fact, the only way Debbie was able to receive a divorce and custody of the children was when she was beaten so severely that the police convinced her to file charges. It was not long before they planned to arrest him that Glen fled to California to avoid prosecution. Despite the divorce and the abuse, he still wanted to be a family man. Clay attempted to excuse these actions by revealing that their own mother had stayed with their father until his death, a marriage that spanned five decades despite both the abuse their mother suffered and the violent punishments the children were subject to if they misbehaved. Clay attempted to rationalize this by stating that perhaps in Rogers's mind, you had to beat a woman to make her stay fifty years.

In California, Glen Rogers would marry again, this time to a woman named Kathy. They had a son together, but this marriage was short-lived too. Clay believes that having a family of his own was "Glen's reason for living and attempt of living a regular life." He thinks that this would have been the stressor that caused him to spiral out of control. Perhaps this is when Rogers became addicted to drugs that would ultimately increase his violent tendencies.

Sue noted the irony of the law at the time prior to Glen's birth. Her parents had to go to court in order to obtain a tubal ligation procedure for her mother. It was not medically necessary for their mother, Edna, to obtain such a procedure, but it was desired because the family was extremely poor and already had five children then to support. The judge denied the request because there was no medical necessity for Edna to have the procedure. All pregnancies and the resulting children were healthy. Edna also had no lingering medical issues. It was not long after that Edna became pregnant with Glen.

Clay wrestled with the idea for twelve days whether he should turn his brother in—it would be later revealed that Clay had also just been released from jail when he discovered the body of Mark Peters, an elderly gentleman and a friend of their mother's who had allowed Glen Rogers to stay with him as a favor to Edna. Peters disappeared not long after his house guest moved in. Upon his release, Clay planned to stay in the family's abandoned cabin in Kentucky. In the attempt to make the place more comfortable, he discovered a body that he feared was Peters's. This is after he claimed that his brother had revealed a plan to rob Nicole Brown Simpson, even if he had to kill her.

Clay took the viewer on a disturbing path on how his brother became a serial killer. He was eleven and Glen was eight when Clay brought him along on his first robbery. Due to their severe poverty, they stole food and money to buy food. It was not long before Glen was walking into people's homes while they were in their yards to rob them. He would bring the money to his brother. Another time, when a sister was going to be evicted, Glen Rogers robbed a convenience store and brought her the money to save her house. Clay revealed that when it came to robbery, his brother was a natural; because of his youth, authorities were less likely to punish him at that time. As children, Clay said the brothers learned not to be afraid of the police—after all, when they were caught they'd get food, soft drinks and a nice warm place to sleep. The police were nice to them and would call their parents. It was Mr. and Mrs. Rogers they were afraid of—mostly their father, since he was a raging alcoholic. They were conditioned not to fear the police or even fear being captured by the police, which would figure into how as a teen and an adult Glen Rogers was able to escape prosecution for so long.

Clay admitted that he was reformed by being forced to join the army, where he learned a respect for life. Even though he would ultimately continue to be a thief, he refused to harm people. Clay also revealed that his brother was a criminal informant, which kept him from being prosecuted numerous times. He believes that his brother was given training by various law enforcement agencies that he reported to on how to avoid detection. This likely further conditioned Rogers to believe that he was bulletproof— that as long as he cooperated with police after he was captured, he could do whatever he wanted.

Clay noted that once when they were teenagers, they played with a tarot deck that, he claims, predicted death and destruction for his youngest brother; also, once when they were drinking, they attempted to conjure a demon as a joke. Clay said that he felt like a bug-like demon was trying to pry its way into his mouth. He got scared and stopped. He later asked his brother if he had felt the sensation of something trying to rip its way into his mouth. Glen revealed that he did not fear that the demon they had called would take possession of him, as the demon that already lived within him was powerful enough to counter any others. Clay stated that this is when he felt his brother was suffering from a severe mental illness and was self-medicating with street drugs rather than seeking professional help.

Clay also claimed that he talked his brother out of killing the girl he was living with shortly after another stint Clay spent in jail for robbery. Clay

convinced him he should put some distance between the two of them if she angered him so much. On this trip, Glen repeatedly stated that he wished he had killed the woman since he had by this time killed fifty women, by his own counting. Clay laughed it off as irritation his brother felt for the woman and her housekeeping abilities. Even though he repeatedly hoped that someone would catch them or confront them upon their hustling in night clubs or their robberies so he could kill them, Clay told him that they did not have to hurt anyone in order to steal. One night, though, Glen went out alone and returned early the next morning covered in blood and wearing torn clothes. Clay covered for him and convinced him to clean up. He also got his brother to dispose of the clothes before they left to keep him from getting in trouble.

Clay attempted to go straight after the road trip and got a regular paying job. Glen asked him repeatedly to help him hide bodies. Clay believed that this was his mental illness talking and that there weren't really any bodies until Glen showed up with a dead body in his truck. He claimed that the body was too heavy for him to hide himself and needed help. Clay swears that he sent him on his way but still did not turn him in to police.

Clay spent time in prison off and on for robberies while his brother was terrorizing the nation as a serial killer. He once spent six months in jail and then went to the family's cabin in Kentucky. It was dilapidated, and the interior was a mess. He went to the back room searching for anything he could use to sit and sleep on but discovered a body instead. He found a note that he believes Glen left for him telling him that he could not hide out there because it would be dangerous for him. Thus began the twelve days during which he wrestled with the idea of turning his much-loved little brother in for murder. The body was later revealed to be that of Mark Peters, their mother's friend. Clay himself was pretty sure that it was Peters. As Peters had always been nice to Clay, it ultimately spurred him to go to the police.

In another twist of irony, the detective who was investigating the disappearance of Mark Peters was Tom Kilgour, the same detective whom Glen Rogers reported to as a criminal informant for the town's drug distribution. Detective Kilgour knew how close the Rogers brothers had always been and knew that Glen had a checkered path with law enforcement. The case was not turning up many leads, so he agreed to take Clay's statement. He admitted how extraordinary it was that Glen's own brother led them to Peters's body and then filled them in on the macabre boasts that Glen had made to him and Sue over the years.

Sue then revealed that while working as a handyman in California, Glen had boasted of how he had done some work for Nicole Brown Simpson

in her Brentwood home and had even gone out with her on dates on two separate occasions. Sue noted that Nicole was married to some famous football player whose name he could not remember at the time but that the two were separated. Glen planned to rob Nicole and even kill her if he had to. Clay first had trouble believing that he had met the Simpsons because of how famous they were. After the very public investigation, Clay began to believe that Glen did kill Nicole Brown Simpson and her friend, Ronald Goldman, even if the Los Angeles County district attorney chose not to prosecute.

It is important to note that after these murders, Glen Rogers is said to have been using an assumed name while hiding out in Van Nuys, where it is thought he had killed his first victim, Sandra Gallagher. After raping and murdering her, he set Gallagher's corpse on fire and then fled California to begin his known killing rampage.

This is when he returned to Mississippi on his way across the country. Linda Price, a beautiful redhead, was a known girlfriend of Glen's. Price's mother revealed that they had met at the Mississippi State Fair in Jackson. Price's mother had invited her daughters to join her at the fair. Linda Price had suffered serious losses in her life after two husbands and a boyfriend had died due to natural causes while she had been with them. A trip to the fair seemed like an ideal way to cheer the family up. Mrs. Price revealed that due to the tragedy in her life, her daughter was looking for the love of her life. At first, Glen seemed like the one. Price's sister Marilyn Williams described Linda as "a great sister, my baby sister, and my best friend."

During the meeting between Glen and Price, Glen is said to have been walking behind her and reached for a lock of her hair, "claiming it was the prettiest shade of red he'd ever seen and she was beautiful." Rogers's mother, Edna, had a similar shade of red hair.

Price was killed on Halloween after Glen Rogers had joined Williams and Price at a bar for the evening. When the two sisters were in the bathroom, Williams recalled Price informing her that if anything should happen to her, she should make sure that Glen was punished for it. She was adamant that Williams promise her that Glen would not get away with anything. Williams was disturbed by this conversation and attempted to elicit more information on whether Glen had hurt her sister or had threatened her, but they were interrupted by Glen banging on the door. He demanded that they leave right then and said that Price had better not be telling her sister anything. When Williams dropped the couple off

at their apartment, she reported that Glen gave her a chilling look and told her, "You're next."

Glen Rogers fled before law enforcement discovered Price's nude body in the bathtub with a washrag covering her face. Sue reported that Glen called her while on the run, and he sounded off. She knew that it was her brother, but his voice sounded different and he could not stop laughing, all while claiming he was with the bodies of two dead girls. His joke was that he was smacking their behinds as he talked to her. He also admitted that she would probably start hearing about his crimes soon and that law enforcement had not scratched the surface of how many victims he had. He claimed that the number was close to seventy by his account. He also said that he would not turn himself in since it was too late for him to do so.

He then showed up in the bars of Bossier City, Louisiana, where he met future victim Andy Sutton and her best friend/roommate, Theresa Whiteside. Whiteside revealed that Sutton believed that she was in love with Glen after one night. Whiteside was chilled when he glared at her as they dropped him off at the bus station the next morning; he said she had better take care of Sutton. She promised she would but thought he was just a random loser her friend had bedded for a night. She expected they would never hear from Glen again. Sutton was also a pretty redhead.

Glen was on his way to Tampa, where he would murder Tina Marie Cribbs in a Tampa 8 motel room. He placed her body in the bathtub before stealing her car, a white Ford Festiva. Clay feels he is able to explain the reasoning behind placing his victims in a bathtub with the shower running overnight, as it would wash the blood away so it did not leave a mess. He did not attribute this to a conversation with his brother—it was simply stated as a point of fact to him.

After Cribbs's murder in Tampa, the Mississippi police, namely Detective Chuck Lee, who was investigating the case, received a call from police in Tampa about how Glen was a suspect in the murder of Linda Price and Tina Marie Cribbs. Detective Lee was the first to make the connection between these two cases and a few others, believing that the killer was Glen Rogers.

Since Glen was not being reported nationally as a serial killer when he returned to Bossier City, Louisiana, no one knew that he should be considered armed and dangerous. Certainly not Sutton, who affectionately referred to him as her "baby" in a conversation with Whiteside. The morning after his return, Whiteside believes she woke up around 10:00 a.m. to the sound of someone knocking on the door. When she discovered it was an ex-boyfriend that Sutton had wanted to reconnect with before

Glen returned, Whiteside asked the man to wait a minute, as she wanted to avoid an awkward moment since she believed her friend was still in bed with Glen. She knocked to give the couple an attempt for decency, but when no one answered, she called out to her friend, came in and affectionately nudged the body on the bed, assuming that it was her friend fast asleep. When calling her name and nudging her failed to rouse her, Whiteside tugged at the blanket to reveal a pillow covering a nude body. She claimed that she was not sure if the body was male or female at first, but sadly, she realized very quickly that it was her best friend.

Bossier City police officers responded to a suspected homicide call at the apartment Whiteside and Sutton shared. Kenny Hamm was the detective assigned to the case. Detective Hamm revealed that in a pile of dirty clothes next to the bed there was a large butcher knife that he believed to be the murder weapon. Hamm noted that in addition to the mortal wounds, Sutton had attempted to defend herself. He interviewed Whiteside, who believed that Glen had spent at least part of the night there; his truck was still in the parking lot. Hamm entered the name Glen Edward Rogers into the National Crime Information Center (NCIC) and got a hit. He learned that Glen was the suspect in many other murders and that Detective Lee of Mississippi believed he was a serial killer.

Reporter Paul Schaefer in Cincinnati visited Edna Rogers in the hope that perhaps she could convince her son to surrender peacefully. Schaefer made the connection that the reason redheads seemed to be the primary targets of his rage was that he was symbolically killing his mother. This type of symbolism was also true for serial killer Edmund Kemper, whose rage was focused on his mother. Once Kemper was presented the opportunity to kill his mother, he peacefully surrendered himself to police and admitted to all his crimes, as well as his mother's part in the crimes. Schaefer did not want any more victims, especially Edna Rogers, whom he felt sorry for.

When Glen called Sue, she urged him to turn himself in—they could talk to the police and he could get life in prison rather than die in a standoff with the police. Glen warned his sister to stay away: "I'm not sure if I'd kill someone I'm related to."

Although to the reporter Sue denied that she believed Glen would kill his mother, she admitted that Edna finally began seeing the similarities in the women who were killed and herself. Mrs. Rogers was fearful that her son was now on his way back to his hometown to kill her and her boyfriend, Bob, before he would stop killing—it was revealed that after Mr. Rogers was crippled due to a stroke, Mrs. Rogers began dating Bob even as she nursed

her ailing husband. Once Mr. Rogers died, Mrs. Rogers quickly moved her boyfriend into her home. This likely further incensed Glen.

Schaeffer reasoned that such a murderer might focus on victims who did not resemble the abuser but rather the person he perceived should have protected him *from* the abuser. He believes that Glen's aggression was focused on his mother since she did not protect him from his father.

Most of the women had red hair and a similar body style to his mother (the auburn-haired Whiteside escaped his rage). It finally dawned on Glen, or perhaps he knew all along, just why he had been killing southern redheads. He admitted to his brother that when he came for their mother, Clay would have to kill him or Glen would kill them both. Glen believed that this was the will of the demon inside him—Glen had outlived his usefulness to this thing, and it would need a new host. But Clay refused the idea.

On the day Glen Rogers was captured, he was not far from the family's cabin in Kentucky. He was on his way to kill his mother when he was spotted driving Cribbs's white Ford Festiva. He had been drinking and continued to drink during the high-speed chase that ensued. He would roll his window down and throw the empties out the window. Detective Bob Stephens of the Richmond, Kentucky police department revealed that one hit the hood of his car as he chased Glen. Detective Stephens also believed that the high-speed chase would end in a shoot-out. The FBI made the decision to fly Clay in to act as a negotiator in the event Glen tried to shoot his way out or commit suicide by cop. Troopers were able to run Glen off the road just outside Waco, Kentucky. Clay revealed that Glen was driving nearly one hundred miles per hour trying to escape the police.

While questioning Glen, Detective Stephens alluded to four or five killings being attributed to Glen Rogers, who quipped that it was not "four or five but more like seventy." Detective Stephens does not truly believe that he killed that many, but since he did not spend much time with the victims, he believes the number is more likely between fifteen and twenty.

Schaeffer then revealed that law enforcement could not be sure of exactly how many murders Glen had actually committed. Many departments began to reexamine their unsolved cases over the previous years to determine if any suspected victims of Glen shared any similarities to their cases.

Detective Chuck Lee of Mississippi concurred, as his phone was ringing all day for several days for law enforcement agencies all over the United States and Canada. Officers were reviewing unsolved homicides during the time when Glen was said to be traveling across the country. They were looking for a glimmer of hope that perhaps their cases shared a similarity

to those involving Glen, who was now recognized by law enforcement and the media as a serial killer. Reporters also were calling Detective Lee and investigating unsolved homicides for which Glen had been in the area during the time of death. One reporter's investigation revealed at least two more victims found in fire pits at the Rogerses' old cabin in Kentucky.

Even though Glen attempted to fight extradition to Florida, since that state had the death penalty and was passionate about actually executing inmates sentenced to die, he ultimately lost and was sent to Florida to stand trial for the murder of Cribbs. Florida had a better case than most states, as Glen was captured while driving her car, with many of her personal items inside (that he could have pawned for money rather than perform other robberies); perhaps he kept them as mementos of the murder. Florida's active rate of execution of Death Row inmates who had exhausted their last appeals quickly won out over Glen's desires and those of Kentucky to keep him there.

Glen Rogers was convicted of Cribbs's murder and sentenced to death. Two years later, California would also convict Glen of Gallagher's murder and sentence him to death. Since two states passionate about enforcing the death penalty had convicted him, and since he could only die once, many states chose not to sit back, instead working to ensure that Glen would not be released on a technicality in either state.

An FBI profiler named Anthony Meoli began corresponding with Glen in an attempt to determine what motivated him. Glen admitted to this agent that he had killed his first woman at the age of thirteen and that his father had helped him cover it up. His father told him that snitches were the worst sort of people and then helped him dispose of the body. Glen was not sure if his shoving the woman down the stairs was what killed her or if his father had finished her off after the fall. His father made him believe it was him and refused to have anything to do with him—perhaps as a domestic abuser who preferred beating his wife and defenseless children, he was afraid that his youngest son would turn his anger and violence on him. Mr. Rogers had little to do with his youngest son after this but warned Glen not to tell anyone about what had occurred.

Glen admitted that he wanted his mother's approval because he thought the female victim was his father's mistress and she had called his mother a bad name. He wanted to proudly tell her that he had defended her, but he was still very frightened of what his father would do if he told.

SSA Meoli also asked him about comments he made about the murders of Nicole Brown Simpson and Ronald Goldman. Since he could not die more than

once, he told him that O.J. had paid him to steal a pair of earrings that he had given to Nicole before their separation. He claimed that O.J. told Glen that he might have to kill Nicole. The Simpson defense team had created a compelling argument that it was *two* people who had killed Nicole and Ron, so there had to have been some sort of proof of his claims. Glen painted the murder weapon and revealed how he had been able to kill both without much of a struggle. He claimed that O.J. had told him where the spare key was hidden, and when he saw Goldman, he knew that he would have to eliminate him in order to secure the earrings. He claimed that Nicole surprised him when he was stabbing Goldman, and he stabbed her once but she passed out. He then returned to finish off Goldman before returning to Nicole to slit her throat to ensure that she was dead. He then entered the house to rob it. Forensic expert Dr. Henry Lee identified two shoe prints in the blood of the crime scene—one shoe was a rare, expensive Italian loafer in the size of the sneakers O.J. wore, and the other was a normal, inexpensive shoe that could be bought anywhere.

As another form of proof, shortly after the candlelight vigil held by the families of Nicole Brown Simpson and Ron Goldman revealed the mourners to be wearing angel pins (because of Nicole's hobby of collecting angel jewelry), Glen morbidly told the profiler and his brother to look at the pin he had given to his mother, the pin he had convinced her to wear to court while he was on trial: a gold angel pin with a real diamond that was similar to the ones worn by the mourners at the vigil.

When interviewed about the death penalty being handed down in two states and how no charges were pending on any other murder that could allegedly be attributed to Glen Rogers, Mississippi police detective Chuck Lee revealed that he was not angry that Mississippi would not be bringing charges against Glen at this time. California and Florida had sentenced him to death. In Florida, despite a claim of prosecutorial misconduct for a witness testifying about a misdemeanor in California, all of Rogers's appeals had been exhausted (the grounds for the appeal were based on the fact that prior criminal acts are not admissible in court). Both Lee and Price's sister believed that since he was sentenced to death in two places, he'd "get what's coming to him."

As for Clay and Sue Rogers, they were both invited to be witnesses to his execution. Sue adamantly refused to attend because she couldn't bear to see him like that. She wanted to remember him as the innocent smiling baby he had been. Clay admitted that he would attend his brother's execution because he wants his brother to know that someone understands. Clay believes that but for a different set of circumstances, he could have been in the same situation as his brother. He revealed that his brother wishes to be

buried in the Rogers family cemetery, a place where their family has been buried for centuries. He also believes this was one of Glen's favorite places to dispose of bodies—a final joke to law enforcement and the victims' families, to be buried so close to his victims. He revealed a conversation during which Glen told him that the easiest place to dispose of a murder victim was in freshly dug graves of people who had been buried in caskets. His brother would remove the sod and dirt, place his victim on top of the casket and then replace everything.

Clay is not sure how many are buried in the family's personal section of the cemetery. He believes that his brother killed as many people as he claims, or close to it. He also ardently believes that most of the victims are in graves of people buried in that cemetery. After Clay was revealed to be a credible witness who led police to the body of Mark Peters, Kentucky authorities began investigating Clay's new claim. They declined to begin digging up the graves, even the ones in the Rogers family section for which the family has given them permission. Perhaps since Dr. Kathy Reichs, noted forensic anthropologist and writer, has revealed the success of ground-penetrating radar in her own cases and books, this will be the way they search for potential victims. This way they will not disturb the final resting places of so many people or cause undue emotional stress on surviving family members.

Clay then made a passionate appeal to his brother to come clean about the location of the other bodies. He feels that since he cannot escape punishment for the crimes, this would give the families some closure about what has happened to their missing relatives.

Even though the Van Nuys, California district attorney who convicted Glen Rogers of the murder of Sandra Gallagher had forwarded apparently credible proof that Glen had been at least complicit in the murders of Nicole Brown Simpson and Ron Goldman, it was not used by Los Angeles Country prosecutors. The Van Nuys District Attorney's Office believed that the information was ignored because they were prosecuting O.J. Simpson at the time and were adamant that he had been the hands-on killer rather than only the instigator. Simpson's defense team investigator revealed that they also ignored the fact that an additional connection was made. The company that Glen worked for at the time used the type of truck that was seen across the street from the crime scene, and an eyewitness who saw the initial confrontation was adamant that the person who confronted Ron Goldman was not black or as broad-shouldered as O.J. Simpson is known for being.

Despite this evidence and the fact that O.J. was found not guilty, the documentary ends with the information that as of November 2012, no

charges had been brought against Glen Rogers in connection to the murders of Nicole Brown Simpson and Ronald Goldman.

GHOSTS OF COLUMBUS MURDERER

A string of murders in Columbus, Mississippi, between 1996 and 1998, including about five senior citizens, became known as the Ghosts of Columbus murders. Mack Fowler, seventy-two, died in July 1996. Police believe that he was the first of the victims of a serial killer who would go unknown for two decades.

According to the *Clarion-Ledger*, a man named David Murray is on trial for the murder of Mr. Fowler after DNA taken at the scene was matched with DNA taken from Murray after an arrest in Jackson, Mississippi, on unrelated charges. Murray had been a guest in Mr. Fowler's home the night of the murder. Since Murray is a burglar and had items of Mr. Fowler's in his possession, the case is being tried as a capital offense due to the underlying robbery. Columbus mayor Robert Smith told the *Clarion-Ledger* that "it's his understanding that Murray confessed to the Fowler murder."

Other victims attributed to the alleged serial killer were George Wilbanks, Robert Hanah, Louise Randall and Betty Everett. They lived within the same three-mile radius. In 1995–96, addresses where Murray is said to have lived in Columbus were also within the same radius.

If Murray is the killer, this was his geographic comfort zone, potentially making him a non-nomadic serial kiler. Mayor Smith's comments to the *Ledger* give the impression that the police informed him that it's unlikely Murray was responsible for any murder except Mr. Fowler's, despite the similarity to the MO of all the other killings.

Another man, Ernest Talley, was arrested in 2012 for the murder of George Wilbanks. Even though Talley was arrested and went to trial for this murder, he was not convicted. The case had to be dropped due to insufficient evidence.

After officials previously believed that the murders were the work of a serial killer, the arrest of Murray and a CBS documentary led officials (not police) to now claim that it was wishful thinking to assume that all five murders were committed by the same killer. The CBS documentary, an episode of *48 Hours*, seemed to shame a former mayor interviewed by the

Beautiful, historic Columbus was home to a series of murders by an unknown person or persons. *Wikimedia Commons.*

local Columbus newspaper, the *Dispatch*, as it made the historic and beautiful Columbus look more like Mayberry, complete with hick cops. The *48 Hours* special embarrassed many of the people involved and made them look like they panicked and jumped to conclusions.

George Wilbanks was stabbed and strangled in November 1997. He was the second victim associated with the series of killings attributed to the alleged Ghosts serial killer. The time between the killings was initially believed to have been the cooling-off period of a serial killer.

The male victims up to Robert Hannah were only stabbed and strangled. Hannah and the female victims, Randall and Everett, were

strangled after they had been bound and gagged. Another oddity or deterrence from the MO was the fact Mr. Hannah's house was set on fire in an apparent attempt to destroy evidence. His body was discovered when firefighters answered the call.

One police officer in Columbus, Selvain McQueen, had been a lieutenant when the killings occurred and was now the chief of police. He was quoted by the *Dispatch* as saying, "I never thought this was a serial murder," and added that he believes more arrests will be made in connection to these other deaths.

Since DNA evidence is what placed Murray in Mr. Fowler's home on the night of his death, it is more than just a possibility that the reason Mr. Hannah's house was set ablaze was to destroy evidence at the scene. Mr. Hannah was one of the younger victims, and since neither the *Ledger* nor the *Dispatch* reported that Mr. Hannah was one of the victims who was bound and gagged before his attack, it is possible that he fought back. Defensive wounds or wounds inflicted on his attacker could have left blood evidence at the scene. Even though forensic science was in its infancy at the time of these crimes, blood could still be typed. If a suspect were available, then a sample of the suspect's DNA could be compared to the evidence to see if the type and antibodies were a reasonable match.

Fire is often either a portion of a killer's MO or is used to cover up evidence of a crime. As with the Glen Rogers case, the perpetrator often believes that the evidence has to be totally destroyed.

THE VAMPIRE RAPIST OF MISSISSIPPI

Since the man suspected of these particular crimes has not been charged, he cannot technically increase the number of serial killers in Mississippi. The Vampire Rapist is alleged to be a serial killer who falls under the category of a sexual sadist. Beating and rape are parts of the signature of this killer. The manner of death can be a gunshot, strangulation, beating and, in the case of one victim, stabbing.

Police have a suspect in mind, and five of the ten bodies attributed to this serial killer were found a short distance from this suspect's home. This includes the one female victim who was stabbed. The suspect in question has been arrested eleven times for multiple incidents, eight of which were assault.

Lack of evidence and reluctant witnesses are the official reasons why no murder charges have been filed and little time has been served by the suspect in question. However, Ricky Franklin, the man authorities believe is the serial killer in question, was convicted in 2012 for an attack that took place in 2009. He was charged with rape, sexual battery, kidnapping and aggravated assault. Of these charges, Franklin was only convicted of kidnapping and aggravated assault. The jury could not come to a decision on the other chargers. The investigators claim that the victim reported to them that "he tried to bite off her ear."

Hinds County DA Robert Smith related in an interview with WAPT-TV that Franklin has a tendency of doing strange things, including attempting to suck blood from a victim's nose. DA Smith then confirmed that Franklin was the suspect being investigated for ten murders, but as of that interview, no charges had been filed due to lack of evidence.

If witnesses believe that Franklin was their attacker and were afraid to testify due to the extreme level of violence each of these women experienced, then these convictions can hopefully put their minds at ease. The two counts Franklin was convicted of in Hinds County carry hefty sentences. He could face up to fifty years for the two guilty verdicts, ensuring that he will be off the streets for a considerable amount of time. If he is the killer, perhaps his lengthy sentences will encourage other victims to testify as well and end the spree of a potential serial killer.

Pete Kotz at True Crime Report has a different idea as to why no other charges have been filed against Franklin. His opinion is pure conjecture, but he believes that the poor credibility of two alleged victims is the reason for lack of additional charges being filed. He claimed on his blog that one of the alleged victims was interviewed by WLBT-TV and declared that she had been kidnapped by Franklin. Her status as a self-described prostitute and drug user made her less than credible, despite the fact that she identified Franklin and his vehicle. This woman made a report, but Kotz said that police did not follow up on the complaint.

However, Kotz wrote that the next woman who was attacked had gone to a bar with Franklin before he allegedly tricked her into riding with him to pick up something he forgot at his home. She claimed that Franklin attacked her in his home before one of his family members showed up and interrupted the attack. This woman's complaint to the police was taken seriously. It may have taken some time, but this woman received a modicum of justice, as this is the case in which Franklin was convicted of kidnapping and aggravated battery. The jury had trouble believing that the

sex had not been consensual in the beginning, however. It seems that the jury had little trouble in ascertaining that the abuse she suffered physically was not requested. For forcing her to stay in his home and beating her, Franklin could spend the next fifty years in jail.

This woman's bravery will hopefully encourage other potential victims to come forward, especially since it will be quite some time before Franklin would be eligible for parole if he is given the maximum sentence as described by the district attorney. With Franklin off the streets, the district attorney could study the bodies of the ten other victims, especially the five who were located close to Franklin's home.

EVIL FOR THE SAKE OF EVIL

The evil men do lives after them; the good is oft interred with their bones.
—William Shakespeare

The following murders are about either violence for the sake of violence or greed. The adage that money is the root of all evil could not possibly predict the evil things that human beings could do to one another just for the sake of it. Even worse are the cases for which there are no answers or the cold cases where questions can take years, even decades, to be answered. The unknown aspect, on top of the heinous nature of the crime, must be unbearable to the victims' families.

Perhaps it's most disturbing when the manner of death is to torture as well as to kill. For the family of Jessica Layne Chambers, whose death makes no sense even though the alleged killer is on trial, her brutal execution included torture that would most likely have caused her a most horrible death if the killer had not expedited matters by setting her ablaze.

A murder due to greed seems to be easier for police to solve and gives a reason for the tragic loss of a beloved family member. The family may not understand why it had to be a member of their family, but it does offer some answers to the many questions they must have. For victim Joey Fulgham, his life insurance policy was to provide for his three children, but his wife, Kristi, seemed to have other plans. Kristi Fulgham was seduced by evil and greed. Organizing a life for herself, her new boyfriend and her children, she planned the murder of her husband for more than a year with her alleged

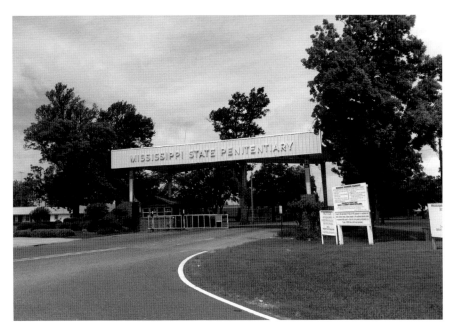

A modern-day photo of the Mississippi State Penitentiary, also known as Parchman Farm, located in Sunflower County. *WhisperToMe, via Wikimedia Commons.*

accomplice, but the attention she gave to the young man started way before she began a plan to kill Joey. She had to ensure that her younger half brother, Tyler Edmonds, worshiped the ground she walked on. She hoped that this devotion would be her scapegoat in her murderous plans. Then she would be free, while the young man who clung to her at a troubled time in his life would be sent to prison for the rest of his life.

JESSICA LAYNE CHAMBERS

The question of who killed beautiful nineteen-year-old Jessica Layne Chambers has been a matter of debate since her horrific death on December 6, 2014. While police have a suspect in custody, his trial is still ongoing. Jessica was not simply murdered. She was tortured, and someone poured lighter fluid down her throat and then set the poor girl ablaze.

No parents should have to bury their child. Even worse was when Ben Chambers and his wife, Debbie (Jessica's stepmother), were returning from

Christmas shopping—they followed Mississippi law and pulled to the side for an ambulance answering an emergency call. Little did Ben and Debbie know that the ambulance was responding to the frightening visage of a young girl stumbling down the street on fire in tiny Courtland, Mississippi. It was their beloved Jessica.

Friends and family mentioned to *People* magazine that before her death, Jessica had been hanging out with a rough crowd, but within months of her death, her family revealed that she had been regularly attending church and preparing to attend college. She seemed to be getting her life back on track, leading people to wonder if she perhaps stumbled into something that frightened her enough to leave the rough crowd behind. Were these people shutting her up before she could reveal something about them? After her death, many of the gang leaders came forward to ardently deny any involvement with this young woman's death.

Even one of Jessica's ex-boyfriends, Bryan Rudd, could not believe that her own actions could have caused such a violent death. In an interview with an independent news source, Rudd revealed an even more disturbing insight into Jessica's brief walk on the wild side. In an audio interview with *Got News*, Rudd made a startling claim that Jessica's father was a very vocal racist who did not understand why Jessica seemed to like dating young African American men. Rudd himself is a young African American man who moved to Iowa and spoke to *Got News* in 2015, revealing that while Ben Chambers would treat her like a princess in some instances, he would also punish her anytime she dated someone who was not white. Rudd claimed that the abuse became so bad that Jessica moved in with Rudd's mother for about five months. He also revealed that Jessica had been raped twice previously by gang members and that these gang members were convicted of the assaults. In 2015, when the interview was conducted, these men were in jail for the crimes. Rudd also alleged that Mr. Chambers is a suspect in two different homicides, one being an ex-boyfriend of Jessica's and the other involving a meth lab that allegedly was owned by Jessica's father. Rudd said that Chambers was arrested by federal agents. Despite claims that Jessica was not a drinker, drug user or smoker, Rudd noted that the two of them used to smoke weed together and that Rudd's mother informed him that she feared Jessica was involved with harder drugs. Rudd wondered if the man held responsible for killing Jessica was the actual killer, why was Jessica found in a white area of town?

Got News reported that several "conservative" websites made claims that Rudd was a member of a gang and that this was a part of why he moved to Iowa. They then chose to get Rudd's point of view, though. Rudd was

quick to say, from the safety of another state, that a friend of his was known to be abusive to Jessica. However, it does not appear that the suspected abusive boyfriend or ex-boyfriend is the same as the man who was arrested in connection to Jessica's murder. At the time of the interview, officials did not have much evidence of who the killer was; Rudd revealed that the abuser was in jail for other crimes.

Some authorities, including District Attorney John Champion, noted that Quinton Telis, a man slightly older than Jessica who grew up down the street from the Chambers and attended the same high school, was responsible for her death. At the time that Champion filed murder charges against Telis, he was sitting in a Louisiana jail on charges of credit card fraud. The owner of the stolen credit card was an exchange student from Taiwan named Meing Chen-Hsiao, and her dead body was found in August 2015. The manner of death was said to be torture and stabbing. The charges that Telis was facing in Louisiana included the possession and use of stolen credit cards, but the discovery of Hsiao's body would cause investigators to start investigating Telis as her killer.

In an interview with *People*, Debbie Chambers stated that due to the trauma inflicted on both her stepdaughter and Hsiao, Telis most likely has killed even more women than these two. Journalist Christine Pelisk, at the time of her article's publication, could not discover if a plea had been entered in a trial against Telis for the murder of Hsiao.

DA Champion was able to find evidence that Telis was the last person to have been in contact with her prior to Jessica's death. Debbie Chambers revealed that Jessica had only known Telis for about twelve days before her death, despite the report that they grew up in the same neighborhood.

Investigation into who killed Jessica took two years before a solid case could be made and a suspect charged. That's two long years the family had to endure, not knowing who did it or why this beautiful young woman was tortured so heinously. In another interview with reporters, Jessica's father, Ben, stated that "doctors and police said they believed someone had poured lighter fluid or something like it down her throat before setting her on fire." Even though Jessica was burned so badly that she was physically unrecognizable, she was able to tell first responders her name and the first name of someone, believed to have been her killer. Her father believes that Jessica tried to tell the police who attacked her.

In an interview that Mr. Chambers gave to the *Huffington Post*, it was revealed that Jessica's cellphone had the battery removed and was tossed into a ditch. The person who killed her clearly did not want police to check his victim's call

history. Mr. Chambers also revealed to the *Post* that she had been visiting her mother and getting her car detailed before the attack. An hour and a half after Mr. Chambers learned that she would be visiting her mother while he went Christmas shopping with his wife, police informed Mr. Chambers that Jessica had died in a Memphis hospital. WFLA-NBC told the *Huffington Post* that the initial autopsy report revealed that Jessica's cause of death was severe burns that encompassed 98 percent of her body.

Mr. Chambers claimed that he did not know of any enemies his daughter may have had, despite his wife's later interview with *People* relating that Jessica had briefly associated with a rough crowd. This also conflicts with Rudd's interview noting that Jessica had been raped twice previously by gang members and that these two gang members had been convicted of these crimes. Rudd's allegations about Mr. Chambers's prior alleged criminal history also points to a list of suspects who might have wished to do Mr. Chambers harm by targeting his daughter.

In the same interview, Mr. Chambers claimed that Jessica did not use drugs, smoke cigarettes or drink alcohol. He stated that she was preparing to go to college and was attending church regularly before her death.

According to an article written by Therese Apel and printed in the *Hattiesburg American* via *USA Today*, Telis, the accused, was a validated member of the Insane Vice Lords street gang. Interestingly, shortly after her murder and the investigation began, several other gangs stepped forward to assure the family and the police that they were not involved with Jessica's violent murder. For a girl with no enemies, discovered in a white area of town, it is odd that they would voluntarily step forward in an active police investigation to reassure police that they were not involved. Were they afraid of reprisal because her alleged boyfriend at the time, Quinton Telis, was a member of the Insane Vice Lords or because of the alleged criminal history of Jessica's own father?

If Rudd's accusations are true, then how was Mr. Chambers able to secure a job with the Panola County Sheriff's Department? Even with the suspicions of homicide and manufacturing of methamphetamines aside, the story that Jessica's father was captured when his meth lab was raided would seem to disqualify him from employment.

Apel's articles appear in many local newspapers, and according to the tenets of journalistic integrity, you should get more than one form of corroboration. It is hard to believe, then, that she would claim that Mr. Chambers worked in the Sheriff's Department if it could not be verified. This would seem to invalidate the claims that Rudd made about Jessica's father's alleged criminal activity.

In a bizarre twist of fate, Telis was held in a Panola County Sheriff's Department cell despite being tried in DeSoto County in connection with Jessica's murder. Apel is the one who revealed that Jessica, a former cheerleader, was romantically involved with Telis before her death. Despite the police confirming information that he was a gang member, there was information on the street that Telis was considered to be a solitary figure.

Apel further discovered that while Telis was in custody, even more evil deeds were brought to light. In the midst of searching for Jessica's killer, police discovered other crimes related to gang and drug activity. In a broader scope, it was called "Operation Bite-Back," which allegedly led to the indictments of seventeen suspected members of three different street gangs on a variety of crimes including child endangerment, possession of stolen firearms, narcotic sales, felon in possession of a firearm and possession of counterfeit currency. Telis was arrested in Louisiana for using the credit card of a murder victim. Apel revealed that none of the seventeen people arrested in the sting were arrested in connection with the murder of Jessica Chambers. Instead, Sheriff Dennis Darby told Apel that he is "100 percent convinced Telis will be convicted for the murder of Jessica Chambers."

Apel revealed a detail of Jessica's parents' behavior once Telis was charged in connection to their daughter's murder. Despite their extremely vocal statements and the interviews they gave to news outlets that seemed to begin shortly after her murder, they continued to celebrate Jessica's birthday, February 2, just as they have done each year since her death, but they also posted statements of grief via social media accounts, as well as posts on Jessica's stepmother's favorite holiday, Christmas.

Apel believes the reason for Jessica's parents' behavior is because Telis is on trial. Since the case is ongoing, the parents have kept their thoughts, fears and hopes on the trial to themselves. DA Champion believes this is the best course of action: "Right now we're just trying to make sure all the things are done the way they're supposed to be done. We're not trying to put any more information out there that isn't already out there."

Apel revealed that as of her February 2017 article, Telis is officially being charged in Louisiana as well for the death of Hsiao but has yet to be brought before the grand jury for an indictment. Apel noted that court documents say that Hsiao's death was slow and extremely painful. Police theorize that she was tortured for the pin numbers to the credit cards that were found in Telis's possession.

Hsiao's death took place on July 29, and her body was discovered on August 8, the same day Telis married his then girlfriend. Telis eventually

pleaded guilty to the charge that he was in possession of and had been using Hsiao's stolen credit cards.

Louisiana charged Telis as a habitual offender. There is a problem as to who is going to prosecute Telis first since each state, Louisiana and Mississippi, is vying for jurisdiction. It seems each state is trying to claim one girl's death as more important than the other. DA Champion is adamant that Jessica Chambers is going to be the first to get justice.

The Louisiana state legislature voted down a measure to abolish the state's death penalty. A Google search discovered a *Fox News* article written by Robert Gearty dated February 2017 that Mississippi has been unable to get drugs needed for the state's chosen form of execution: lethal injections. The last time a person was executed in the state of Mississippi was in 2012.

Mississippi legislator Andy Gipson spoke to Gearty about House Bill 638. Forty-seven people are currently on Death Row in Mississippi. Gipson wishes to bring back other options for the death penalty. Of these options, he wishes to bring back the use of the firing squad, the electric chair and the gas chamber. Gipson revealed that one of his constituents has a daughter who was raped and murdered by a serial killer more than twenty-five years ago, and the person convicted of that murder is still awaiting execution. The family is still awaiting justice.

According to the Death Penalty USA website, Louisiana's last known execution was in 2010, two years prior to the last person that Mississippi executed. Thus, if the Senate follows the example of the House and House Bill 638 passes, if Telis is convicted of Jessica's murder and if he exhausts his right to appeal, he will be executed swiftly in whatever manner the state determines appropriate.

KRISTI LEIGH FULGHAM AND TYLER EDMONDS

What would make a thirteen-year-old boy confess to a murder he did not commit? For Tyler Edmonds, it was his brother-in-law, twenty-eight-year-old Joey Fulgham, whom he confessed to killing. Could he have thought perhaps he was doing it to protect his much older half sister, twenty-six-year-old Kristi Leigh Fulgham?

Originally, Edmonds told police that he shot his brother-in-law while Kristi had her arms wrapped around him, as if to steady him. Regardless of whether Kristi had been a victim of domestic violence, Edmonds's own

statement to the police revealed that neither of them was in any immediate danger since at the time of the shooting (sometime over Mother's Day weekend in 2004), Edmonds revealed, his brother-in-law was asleep with his back to them.

Edmonds's initial confession to police concerned the positioning of a .22-caliber rifle that he claimed to have held. For whatever reason, fear of being in jail (or something his sister said in her own trial that he became aware of) made him recant his confession. His idolization of a sister twice his age was irrevocably broken, as he spent four years in a juvenile corrections facility for a crime he did not commit. It was revealed that he was outside, perhaps watching his sister's three children, while she killed her husband before leaving for a trip to Biloxi that was to be her alibi.

A common misconception is that a juvenile cannot be convicted of a serious crime with the same punishments that an adult would face. After his release, Edmonds admitted to the *Commercial-Dispatch* that being on trial and having his innocence shattered "was terrifying." Incarcerated for four years, Edmonds would learn that he was the subject of a letter in which DA Forest Allgood defended himself and his decision to prosecute the then thirteen-year-old as an adult. The letter was written in response to a newspaper article's claim that in the case of the brother and sister who plotted murder and made national headlines, Allgood chose to prosecute Edmonds as an adult to keep his own name in the media. He revealed that it is in the DA's discretion how to charge a juvenile offender and cited Section 43-21-15 of the Mississippi Criminal Code, which allows for a child as young as thirteen to be prosecuted as an adult if the crime they are accused of would or could carry a life sentence for an adult. Edmonds was thirteen at the time of his claims that he helped his half sister murder her husband, and it was his confession that brought to light the apparent theory created by DA Allgood during the trial that there were two killers and one gun.

Edmonds did not waste his time while in jail. He finished high school and began taking college classes. During this time, he recanted his confession both to investigators and to his own attorney, Jim Waide. Waide would ultimately secure Edmonds's release after the frightened teen admitted that he had not been in the house at the time. Waide zealously advocated for a second trial for the teenager, and these appeals would take them all the way to the Mississippi Supreme Court. This second trial was featured on Court TV. The state Supreme Court acquitted Edmonds in 2008, and after attending community college to become an EMT, he moved out of state,

hopeful for a clean slate and fresh start despite the murder of Joey Fulgham making national headlines.

A reasonable suspicion would be that Edmonds was an impressionable child, coerced by his much older sister into taking the bulk of the punishments for the murder. Edmonds admitted in an interview for the Oxygen channel series *Snapped* that he had worshiped his sister prior to the murder.

In his interview with the *Commercial Dispatch*, he noted that he is not a supporter of the death penalty but believes that the new sentence his half sister is serving is fitting. Life without the possibility of parole is a more fitting punishment, he believes, because she will have nothing to do but sit in her prison cell contemplating her crimes and all the people she hurt by killing her husband—not just Edmonds, who suffered four years in prison and still has failed to get restitution that Mississippi allows for the wrongly convicted, but her own children, who now are forced to live without an accessible mother or father. By his own admission, the relationship Edmonds once had with his sister was ruined the minute he realized the weight of the seriousness of the repercussions of helping his sister with her lie.

So, why did Kristi Fulgham want her husband dead? What possessed her to get her little brother to claim involvement? Did she honestly think she would escape punishment for the crime by implicating a teenager? Edmonds's original story not only put her at the scene of the crime but also in a position to hinder his attempt to kill her husband, whom people thought she adored. Even if she was physically unable to overpower her brother and take the rifle from him, a struggle for the rifle and her fear for her husband would have made for a loud scene that would have surely awakened her husband. He would have had a chance to escape death and help his wife wrestle a weapon away from her half brother.

Between the two adults, surely they could have thwarted any potential danger they faced from a teenager with a loaded weapon, unless there was the possibility the teenager was on drugs or suffering from a mental state that put him in a manic state that caused his adrenaline to skyrocket. This might have caused his strength to increase dramatically. According to *Scientific American*, "an extreme emotional response can increase strength....[When] we find ourselves under intense pressure, fear unleashes reserves of energy that normally remains inaccessible. We become, in effect, super human."

Perhaps Edmonds could have overpowered his sister. Perhaps Fulgham could have warned her husband that his life was in danger. The fear response should have allowed the two to overpower the adolescent. Unless she was

complicit in the crime, she could have prevented it or hindered it enough that her husband could have fought for his life. He would not have been shot execution-style in the back of the head.

So, a woman not only had her husband killed but also planned it to the extent that she was caring for her much younger half brother at the time of the murder, in order to implicate him as the sole aggressor. A theory that was excluded during Fulgham's first trial was her claim (and that of a social worker, Adrienne Dorsey-Kidd) that Fulgham was not allowed to bond with her parents as a baby, in addition to the introduction to drug use by her own mother and both of her stepfathers. It was believed that her reasons for killing her husband revolved around drug use. She is said to have robbed his house and killed him for his insurance policy.

The exclusion of Dorsey-Kidd's testimony during the sentencing phase of her murder trial allowed for a sentence of death for Fulgham's role to be reviewed. While it would not excuse her participation in the crime, testimony is often allowed during the sentencing phase to introduce mitigating factors to the reasoning behind a defendant's actions. A heat-of-the-moment bar fight can be the difference maker in the burden of proof as to whether the death was the cause of premeditation or resulted from the trauma the victim suffers during the fight that ultimately led to his death (i.e., a concussion that makes the victim dizzy enough to fall and hit his head). The introduction of Dorsey-Kidd's testimony to the new sentencing phase commuted the sentence from death to life in prison without the possibility of parole because it was reasoned that the addiction caused an impairment to reasonable judgment.

The case of who killed Joey Fulgham and the bizarre twists that made the case national news captured the attention of the Oxygen channel, leading to a special on its television series *Snapped*. The murder trials of Kristi Leigh Fulgham and Tyler Edmonds were the subject of season 16, episode 6 of the popular true crime series. The series attempted to get down to the bottom of why Joey Fulgham had to die. Interviews with family members, Edmonds and police officers are shown during the course of the show. Clips of the show highlight that from the very beginning, the police suspected that Edmonds was being manipulated by his half sister into taking the blame for the murder.

The belief that Kristi and Joey worshiped each other was revealed to be yet another strand in the web of lies Fulgham spread about her life before and after she murdered her husband. Shank Phillips of the Oktibbeha Sheriff's Department was one of the investigators who investigated the murder of

INMATE DETAILS
KRISTI FULGHAM

MDOC ID Number: 117337

Race: WHITE	**Sex:** FEMALE	**Date of Birth:** 08/27/1976
Height: 5' 4"	**Weight:** 155	**Complexion:** FAIR
Build: MEDIUM	**Eye Color:** HAZEL	**Hair Color:** BROWN
Entry Date: 01/26/2006	**Location:** CMCF	**UNIT:** CMCF QB
Location Change Date: 11/01/2016	**Number of Sentences:** 3	**Total Length:** LIFE

OFFENSE 1: ESCAPE-JAIL (ATTEMPT)

Sentence Length: 4 YEARS **County of Conviction:** OKTIBBEHA **Sentence Date:** 01/24/2006

OFFENSE 2: POSS CONTRABAND IN PRISON

Sentence Length: 8 YEARS **County of Conviction:** OKTIBBEHA **Sentence Date:** 01/24/2006

OFFENSE 3: CAPITAL MURDER

Sentence Length: LIFE **County of Conviction:** OKTIBBEHA **Sentence Date:** 12/09/2006

*Please note that due to state laws release types and release dates may differ from the information listed on this website.

Kristi Leigh Fulgham's rap sheet. *Mississippi Department of Corrections.*

Joey Fulgham. During the interview he gave to *Snapped*, he said that what Kristi did to Tyler was "evil."

Rumors that Kristi was cheating on Joey spread like wildfire in the tiny town of Longview, Mississippi. Kristi left Joey briefly after fighting with him for several months over these rumors. When she returned, she was pregnant, and in an attempt to work things out with Joey, they went on *The Montel Williams Show* for a DNA test. Even though it proved that Kristi was cheating, Joey agreed to care for the child, a little girl, like he did for the boy and girl he had with Kristi. It was Joey's idea to get a DNA test.

Tyler Edmonds was interviewed by *Snapped* about his involvement with the case, and he stated that they were on their way back from Biloxi when police called to inform Kristi about Joey's death. After the initial notification, several calls began to come in, and after repeatedly asking his older sister what was wrong, she finally told him that Joey was dead. Tyler says she began to cry, and so did he. He says the kids were also upset even though they were too young to understand what was going on.

Kristi and Tyler's father told the police that Kristi had asked him for a gun because Joey had a life insurance policy that was worth $300,000; in exchange for the gun and his silence, Kristi promised to buy him a Cadillac. He refused, and after several people failed to get her a weapon, she finally asked Tyler to get her a gun. His stepfather had a rifle in his closet that was allegedly his grandfather's gun. He believed that no one had used it, and he did not even believe that it would work.

Kristi attempted to get information from the insurance agent about Joey's life insurance policy since she was the sole beneficiary when Joey first bought the policy. The agent refused to discuss the policy with her, even though she was Joey's wife, without Joey's permission. Perhaps it was the fact that in 1999, Joey had changed the policy to make his mother the primary beneficiary. Under the terms of the restructured policy, Kristi would only receive $55,000.

When arrested, Kristi initially claimed that Tyler had been playing with the rifle and was pretending to shoot Joey when the gun accidently discharged. In order to protect Tyler, she told him to help her tear the house up to make it look like Joey had been murdered during a robbery. Kristi intended to put all the blame on Tyler. She even tried to provide him with an excuse that Joey verbally abused him by calling him a "sissy boy" and "faggot." Investigators revealed that Tyler was small for his age and had a rough life, but he would have done anything to protect his sister—even initially take the blame for being a part of the murder.

Tyler was reportedly only in custody for a few days before he was frightened enough to recant his initial confession that he and Kristi had shot Joey together. During interrogation, he said that he had originally gone with what Kristi had wanted but got scared. So, he invented the story that she steadied him and pulled the trigger while he held the gun. He said that even though Joey had been killed, they did not go to the Sheriff's Department or her home. They went to her mother's home, where she sobbingly laid out her plan to Tyler. She admitted that she killed Joey and needed Tyler to protect her. She claimed that they were going to kill her and that she'd never see him or the kids again. She manipulated him into believing that if he confessed, he would not get into much trouble. His punishment would be more like being grounded, but he would get to go home. Tyler admitted that Kristi had been confiding to him about her plans to kill Joey for more than a year. She said that Tyler was a minor and if he said he did it, nothing serious would happen.

Police knew that Tyler worshiped Kristi and suspected that he would tell the truth out of fear. Tyler admitted that he was scared that since Kristi was his only link to their father, he would never see her or their father again. He was also afraid he would never see his nephew or nieces again. He loved his half sister so much he finally agreed. He did not know that Kristi was planning on pinning the whole thing on him and even told the police that he did not believe his sister would say that to them. The police put the two of them together in a room, and he asked her if they were telling the truth. Kristi cried and begged him to tell them. She said it would all be okay if he just told them. He finally agreed, and police separated them quickly.

Apart from his fear of being in jail, he also realized that Kristi was setting him up. His second visit with the sheriff, during which he recanted, was deemed inadmissible by the first trial judge. Even investigators admitted that it was out of their hands by the time he spoke to the sheriff to recant. It was in the hands of the District Attorney's Office. Tyler was fifteen when he was sentenced to life in prison, and his life was forever shattered.

Ben Bounds, a former reporter for the *Starkville Daily News*, told *Snapped* that Kristi wrote a letter to Tyler while he was in jail begging him to take full responsibility for the crime. She told him to be sure to tell law enforcement that the shooting was an accident. Letters to juveniles are scanned by jailers, and in this case, it aided in proving that Kristi was the mastermind. It was used as a damning piece of evidence by the prosecution in her own capital murder trial. It only took forty-five minutes for jurors to find Kristi guilty.

The investigators said that Kristi was shocked to discover that she was not going to get away with killing her husband. As previously noted, she was initially sentenced to death.

Mr. Waide, Tyler's attorney, revealed that Tyler got a second trial because the judge failed to allow him to introduce evidence that Tyler had recanted his initial confession and that there were police officials willing to verify that he had come forward to recant. This trial was the one that was aired on Court TV, and images shown on *Snapped* show a relieved nineteen-year-old Tyler breaking down in tears to learn that he was found not guilty.

In 2010, when Kristi's death penalty conviction was commuted to life in prison, she agreed to waive all rights to any future appeals as long as the state dropped any further steps to fight the overturned death penalty punishment.

THOMAS E. LODEN JR.

On June 22, 2000, Thomas E. Loden Jr. kidnapped sixteen-year-old Leesa Marie Gray. Over a nearly four-hour period, Loden raped and sexually battered Gray before suffocating and manually strangling the girl. Loden also videotaped portions of the sadistic acts he visited on his helpless victim.

Loden was indicted for capital murder, rape and four counts of sexual battery. The underlying crimes make the murder a capital offense; if convicted, Loden could be eligible for the death penalty. On September 21, 2001, Loden waived his right to a jury for trial and sentencing. He pleaded guilty to all six counts of the indictments. The Circuit Court of Itawamba County, Mississippi, accepted those pleas and found him guilty on all counts. He waived the right to cross-examine witnesses and all objections to state evidence. He also chose not to offer any mitigating evidence on his own behalf. Loden addressed the court to apologize to the friends and family of Gray: "I hope you may have some sense of justice when you leave here today."

The circuit court found that all four factors required by Mississippi Code Annotated Section 99-19-101 (7), revised in 2007, were satisfied that sufficient aggravating circumstances existed and that the mitigating circumstances do not outweigh the aggravating circumstances, finding that the death penalty should be imposed.

Loden appealed, and in July 2003, the Office of Capital Defense Counsel filed a "Motion to Vacate Guilty Plea" alleging that Loden's plea was

Itawamba County Courthouse, the location of Loden's trial. *Author's collection.*

involuntary because his "decision to plead guilty was based on inaccurate legal advice given by his trial attorneys."

However, by Loden's own admission, he stated that at about 10:45 p.m. on June 22, 2000, he kidnapped Gray after he found her car on the side of the road with a flat tire. He assured her that she was going to be okay and that he was a marine. He alleged that he asked her if she had ever thought about being a marine, and her response was that it was the last thing she would ever want to be. That angered him so violently that it set him off. He then decided to abduct her and punish her for the perceived slight. He claimed that he was "violently angered."

Loden was discovered lying on the side of the road with "I'm sorry" carved into his chest and what appeared to be self-imposed slash marks to both wrists. Not long after Loden was found, Gray was found nude, bound at the hands and feet, covered with a sheet and wedged beneath one of the fold-down seats in Loden's van.

During his trial, Loden underwent psychiatric evaluation to determine if he was mentally able to stand trial. The state chose Whitfield State Psychiatry

Hospital to do the evaluation. The evaluation determined that he was able to distinguish between right and wrong at the time of the murder.

The average wait time for an inmate on Death Row to be executed is fourteen years, according to an article the *Jackson Free Press* published in 2016. Loden and fellow Death Row inmate Richard Jordan have filed an appeal based on the method of execution Mississippi uses: lethal injection. However, this is a last-ditch effort designed to piggyback on the appeal of another inmate, Ricky Chase, as Jordan and Chase had exhausted all of their own appeals. The article revealed that as of July 27, 2016, the two convicts could be executed at any time.

It is because of these three convicted killers that no executions have occurred since Gary Carl Simmons was executed in 2012. It is the very reason Mississippi legislator Andy Gipson is so passionate about House Bill 638 and his attempt to get the state to authorize other forms of execution. It is a reaction to a federal court injunction that froze executions based on the inmates' motions challenging the state's use of a sedative drug, the first used in the three-part cocktail that makes up the injection.

No execution dates have been set for either Loden or Jordan until the courts or legislators come to a decision on the other manners of execution suggested in House Bill 638.

THE RIDINGS FAMILY

Members of the Ridings family of Monroe County, Mississippi, were murdered in 1880. After the husband and wife were murdered, the house was set on fire. A tramp had been seen in the area and was caught near Tupelo, Mississippi. One report states that the tramp had Mr. Ridings's watch in his possession.

Historians believe that the tramp was named Alvin McKenna. He was in a criminal partnership with a man named John Gilmore. News reports of the time noted that McKenna was taken back to the scene of the crime by his "captors" (unclear whether this meant law enforcement or an enraged mob) and forced into a confession; he then led them to the goods that were stolen from the Ridings family. The assembled mob then attempted to lynch McKenna, but the rope broke. As McKenna writhed in pain, suffocating to death, the mob began to pile wood on him—an ironic twist due to the bodies left in McKenna and Gilmore's wake before coming to Mississippi.

Oral history reports that McKenna said he used the guise of an itinerant farmworker. He would travel around looking for a work and for a family who would allow him to spend the night. He hunted for families who kept large amounts of cash at home. He would speak to poor black workers and shopkeepers, inquiring about farms that might hire him. He chose Mr. Ridings as his first victim. The plan he and Gilmore devised would be to convince the family to let him spend the night and wait for them to fall asleep. He would then drug them before signaling Gilmore. Once they found all of the family's valuables, they would decide what other criminal activities they could commit if the farm were isolated enough.

On the night he chose the Ridings family, robbery was only the beginning. Mr. Ridings was killed with an axe, and then McKenna and Gilmore raped Mrs. Ridings. McKenna then found a can of kerosene on the mantel that they used to douse the bodies of the entire family. They then set the house on fire. McKenna admitted that even though they poured kerosene over the body of the sleeping infant, they did not spare the child by giving him or her a quick death, as the parents had received. McKenna said that he and Gilmore stood outside the house watching the fire and listening to the baby scream.

McKenna claimed that he and Gilmore had at least fifteen other victims that they had burned alive or murdered before setting the houses on fire. While technically the murder of the Ridings family could classify McKenna and Gilmore as serial killers, the bulk of the murders that have been connected to either McKenna or the pair were mass murders. The two other crimes resulted in one crime having five victims, and another had eight victims.

MYSTERY AND MAYHEM

Sometimes there is never a reason given as to why someone commits murder. Such is the case of Ashlee Smith and her victim, bank teller Judy Guin. The answers may never be discovered, as Smith committed suicide shortly after the death of her victim. What about the Water Valley murder mystery? Was it a hate crime or a case where years of abuse at the hands of his employer, who adhered to pre–Civil War ideas in how he treated his African American employees, caused him to so significantly fear for his life that murdering the employer and his wife was his only recourse?

In the 1920s, African Americans were unable to vote, so they could not serve on juries. The jurors who would oversee the Water Valley Axe Murder trial would all be white and most likely members of the same socioeconomic class as the victims of the crime, not the defendants. Due to fears stirred up by the press at the time of the murders, members of the public were extremely afraid that they could be killed while they slept. It was highly improbable that the jury did not already have opinions on the case before it ever learned of the identities of the alleged, and later confessed, murders.

WATER VALLEY AXE MURDERS

May 5, 1931, in Water Valley, Mississippi, was a day like the small town had never seen before. The town was rocked by the brutal axe murders of

Mr. and Mrs. W.B. Wagner. The Wagners were one of the most prominent families in Water Valley. The town was a relatively quiet one by the standards of early Depression-era Mississippi.

The family's cook, Callie, found the house in shambles and blood on the floor. She fled to the neighbors, who called the Sheriff's Department. Sheriff C.T. Doyle determined that a serious crime had occurred. Doyle believed that a struggle had occurred and coordinated a search in order to find the Wagners. The family was nowhere to be found at first, but the deputies soon found a discarded bloody axe.

While police searched the house, neighbors searched the yard. Mr. Wagner was found in a shallow grave in a garden behind the house. His head had been bashed in two places so severely that the skull was entirely caved in. Police described the rest of the body as mutilated. Mrs. Wagner was not in the house or on the property. During the search, blood was discovered on the seat of the couple's Chevrolet sedan. The police were clueless as to why the killer or killers would leave with Mrs. Wagner and then return the car to the initial crime scene.

Sheriff Doyle put the small town on lockdown to trap the killer or killers. Fingerprints were preserved on the axe left behind. Doyle surmised that Mr. Wagner, as president of the Bank of Water Valley and owner of Wagner's Department Store, was the primary target. Since it was the Depression and he was one of the more prominent citizens of Water Valley, he was not short on enemies.

Mrs. Wagner was discovered two miles from the couple's home in a deep gully. It is believed that due to her size, it would have taken at least two people to dispose of her body. It is alleged that her head was covered with sand to cover the contusions and lacerations that liberally covered her face. The fatal blow was discovered to be a slashed throat. Seeing the amount of trauma inflicted on the face and head of Mrs. Wagner and Mr. Wagner, Sheriff Doyle suggested that the murder was an act of revenge.

Doyle chose to interview Callie, the Wagners' cook, first. The only person she saw before discovering the ramshackle house was Sam Whittaker, the Wagners' eighteen-year-old chauffer and "house boy." Whittaker stated that he had not entered the house since the Wagners had left. He also attempted to persuade Callie not to enter the house and tried to get her to return home.

Deputies then brought Whittaker in for questioning. A suspicious red blotch was seen on Whittaker's shoes. Upon closer examination, dried blood was also discovered beneath his nails. At this point, Whittaker confessed to the murders. He claimed that Mr. Wagner slapped him for stealing a

Mr. Wagner's tombstone. *Find A Grave.*

shotgun. He then told deputies that Wagner informed him that the next day he would be horsewhipped. He implicated his younger sister, fifteen-year-old Adelle Whittaker, and Emmett Shaw as his accomplices. Shaw was serving time as a member of a chain gang. However, he was a trusty, and under judicial law of the time, trusties were not locked up at night as regular prisoners were. Shaw was a former employee of the Wagners who allegedly had been fired for stealing. This is possibly the offense of petty theft that had resulted in Shaw's being sentenced to serving on the chain gang. Shaw initially denied the implication that he had aided Whittaker in the murders. When shown the evidence and the testimony of Adelle Whittaker, he finally confessed to participating in the murders. He revealed that Adelle had not aided in the murders or the disposal of Mrs. Wagner. Her only crime was that of keeping her brother and Shaw's secret. She had arrived when Shaw and her brother were burying Mr. Wagner in the garden.

As Shaw tells it, when Mrs. Wagner was first struck, the weight of her body sent her back over the table and onto the floor, leaving blood on the tablecloth as well as the floor on both sides of the table. Before they could do more damage to Mrs. Wagner, Mr. Wagner must have heard the commotion and came to investigate. The two men attacked him as he came in the door. After disposing of Mr. Wagner in the garden, they put Mrs. Wagner into the car and threw her into the gully. Upon impact, Mrs. Wagner cried out in pain, alerting the two men that she was still alive. Shaw stated that Whittaker wished to "put her out of her misery" by climbing down into the gully and slashing her throat. This does not explain the sand that was used to cover her head. Perhaps she was punished because she ignored the abuse that Whittaker alleges Mr. Wagner handed out to employees as punishment. Even though slavery ended in the 1800s, in Mississippi abuse was often used on those who served the upper classes.

Fearing that Whittaker and Shaw would be lynched for their crimes by angry and quite vocal Water Valley citizens, Sheriff Doyle arranged for

Although Parchman is now a male-only facility and was designed as a male-only African American prison, by 1917 the prison was housing male and female, black and white inmates. *Mississippi Department of Archives and History on Flickr.*

the men to be held in the more fortified Greenwood jail while they awaited indictment on the murders. During the trip to Greenwood, Whittaker verified Shaw's previous statement on the events surrounding Mrs. Wagner's murder about how the force of the blow caused her to hit the table and fall to the floor. He told them that he disposed of the tablecloth so the blood would not be immediately noticed. He hid it in a hamper, assuming that when the housekeeper cleaned the laundry, it would be kept quiet. It was found where Whittaker said it was and served as a valuable piece of evidence against the men. Both men stayed in Greenwood jail until the grand jury returned an indictment of first-degree murder for both men.

The trials began on June 10, 1931. It only took the jury a mere eleven minutes to return with a guilty verdict for both men, as well as the recommendation that they be executed for their crimes. The two died by hanging on July 17, 1931, and are believed to be the last to be legally executed by hanging.

For Adelle's silence, she was found guilty of being an accessory after the fact. Despite her age, she was sentenced to serve a fixed sentence of five years, to be served at Parchman.

THE ASHLEE SMITH MYSTERY

Ashlee Smith walked into a branch of the Farmers and Merchants Bank in Mantachie, Mississippi, on June 21, 2017, with a weapon drawn. It's an ongoing puzzle that Itawamba Sheriff's Department and Mississippi Bureau of Investigations is trying to solve. In an interview with multiple newspapers, Sheriff Chris Dickinson revealed that Smith had no prior criminal history and was unknown to law enforcement agencies in Itawamba County and Smith's hometown of Pontotoc, Mississippi.

Investigators revealed to the media that bank surveillance cameras caught Smith walking into the bank with the gun drawn demanding access to the safe. At least three employees were in the bank at the time. One escaped, but the other two were not so lucky. She started to chase the employee who fled, but for some reason, she turned and shot at the two other employees. This was perhaps done to scare them into cooperating, even though it is believed they were already doing so.

Judy Guin, age sixty-four, of Marietta, Mississippi, had worked for this particular branch of Farmers and Merchants bank since it opened in 2006. As a loyal employee of eleven years, she was the only one in the bank at the time who had access to the safe. Unfortunately, Mrs. Guin died instantly when she was hit from one of the shots fired by Smith. It is believed that upon realizing she had lost her chance for the big score, Smith abandoned the other teller, who had her drawer open and was cooperating despite her own wounds, and fled through the bank as if chasing the employee who escaped.

An all-points bulletin was put out for law enforcement to be on the lookout for Smith and the Chevy Tahoe she had used for her escape. It is believed she headed west on Highway 363. Law enforcement officers from Saltillo and Mantachie, Mississippi Highway Patrol and Itawamba Sheriff's Department entered into the manhunt for Smith. Less than fifteen minutes after Smith entered the bank, an officer from Saltillo was joined by a highway patrol officer as they attempted to get Smith to pull over so she could be taken into custody. As they approached their armed fugitive, Smith committed suicide with the same weapon that had taken Mrs. Guin's life.

In a statement to the *Daily Journal*, Sheriff Dickinson indicated that a second video shows that she initially started to chase the fleeing employee before backing up to fire the shot that ended Mrs. Guin's life. Then she went to check and see if the vault was open; she was disappointed first that it was locked and second that she had killed the only one with access.

The courthouse in Ashlee Smith's hometown of Pontotoc. *Wikimedia Commons.*

Wondering why a woman with no history of criminal behavior decided to rob a bank, police investigated whether there was a personal connection between Smith and any of the bank's employees. The mystery grew, as no one at the bank knew Smith and had not seen her before she attempted to rob the bank. Due to this, Sheriff Dickinson initially believed that Smith had not killed Mrs. Guin intentionally. He revealed to WTVA that the video clearly showed that this was not the case.

Comments from online readers provided an interesting perspective, applauding the sheriff for being honest and keeping the public informed about the investigation. One reader who commented was from Saltillo and revealed that Smith's family had apologized for her actions and that Mrs. Guin's husband, a Baptist minister, and their son had accepted the apology by offering forgiveness. This was in response to someone saying that nothing Smith had done prior to the murder and attempted robbery mattered because all she would be remembered for was the fact that she was a "cold-blooded murderer," as the reader posted.

The family did apologize via an interview with WTVA. The article stated that they are mourning with the Guin family, as well as mourning for Smith,

and are "terribly sorry" for what happened. The article revealed that up until that day, Smith had always been a loving and compassionate person. In the midst of trying to find out why Smith's personality took a 180-degree turn, the family noted that they were being harassed by people not involved with the investigation or Guin family—cruel, ugly messages sent via social media. A screen capture of Smith's Facebook page was provided as the leading image to several of the news reports.

Sheriff Dickinson was asked to comment on the family's interview with WTVA. "Ashlee Smith was a model citizen until she entered the bank and he is not sure what prompted her to commit the crime," the paper noted. Just why Smith killed Mrs. Guin and attempted to rob the bank is an ongoing investigation, conducted by the Mississippi Bureau of Investigation.

Was Smith sick with greed or was she suffering from an undiagnosed illness prior to her death, similar to Texas tower sniper Charles Whitman? Whitman was a well-respected former marine and Eagle Scout who killed his wife and mother before climbing the tower at the University of Texas and going on a shooting rampage. Before his rampage, he was attending UT and sought out the campus psychiatrist to report feelings of rage and headaches. He even reported to the doctor that he felt like putting his marine sharpshooter skills to work by climbing the campus's thirty-story clock tower and shooting people. Despite this clear cry for help, the doctor only asked him to come in for more sessions and did not notify the administration or campus security of the potential threat.

Whitman's sharpshooting skills and vantage point allowed him to shoot people up to three blocks away. As a former soldier, he successfully eluded 130 law enforcement officers and a plane with another sharpshooter. A police officer was able to overtake him in the tower but only after he had killed an additional fourteen people and wounded thirty. A letter he left in his home told a story of the headaches and blinding rage. He also requested to have someone inspect his brain after his death to determine why this sudden change had come upon him. An autopsy revealed that his sudden mood change from loving family man and respected former soldier to a raging mass murderer was because of a massive tumor in his brain.

Could this be what made Ashlee Smith go from a caring, God-fearing woman to a cold-blooded killer? The act of taking her own life could have been an attempt to avoid prosecution or perhaps came from an underlying mental or physical illness. As of this writing in August 2017, the Mississippi Bureau of Investigation has not revealed any potential motive or underlying health defects that surfaced during Smith's autopsy.

BIBLIOGRAPHY

Appel, T. "Arrest Made in Columbus Cold Case Tied to a String of Elderly Murders." *Clarion-Ledger*, 2017. Retrieved from http://www.clarionledger.com/story/news/local/2017/05/24/arrest-made-columbus-cold-case/342218001.

CBS News. "Ghosts of Mississippi." 2000. Retrieved from http://www.cbsnews.com/news/ghosts-of-mississippi.

Chicago Tribune. "Man Charged in Murder to Fake His Death." 1983. Retrieved from http://archives.chicagotribune.com/1983/06/10/page/20/article/nation-world.

Investigation Discovery. *My Brother the Serial Killer*. Television Documentary, 2012.

Jefferson, Thomas. The Declaration of Independence, 1776. Retrieved from https://www.archives.gov/founding-docs/declaration-transcript.

Kershaw, S. "Twenty-One Year Hunt for Killer Shapes Man and Family." *New York Times*, 2003. Retrieved from http://www.nytimes.com/2003/11/07/us/21-year-hunt-for-killer-shapes-man-and-family.html.

Kotz, P. "Vampire Rapist Ricky Franklin May Be Serial Killer, but Cops Can't Convict Him." *True Crime Report*, 2009. Retrieved from http://www.truecrimereport.com/2009/11/vampire_rapist_ricky_franklin.php.

Meredith, James. *James Meredith vs Ole Miss*. Mississippi: Meredith Publishing, 1995.

Morton, Robert, SSA. *Serial Murder*. Federal Bureau of Investigation, 2005. Retrieved from https://www.fbi.gov/stats-services/publications/serial-murder.

NBC News. "Ex-Klansmen Convicted in '66 Bombing Is Dead." 2006. Retrieved from http://www.nbcnews.com/id/15579563/#. WXU3EojyvIU.

New York Times. "Mississippi Lawyer, Believed Dead, Held in Murder." 1983. Retrieved from http://www.nytimes.com/1983/06/14/us/mississippi-lawyer-believed-dead-held-in-murder.html.

Safron, J. *God'll Cut You Down.* New York: Penguin, 2013.

Sisson, C. "Columbus Man Arrested in 14-Year-Old Murder Case." *Columbus Dispatch*, 2012. Retrieved from http://www.cdispatch.com/news/article. asp?aid=15687.

Veselka, Vanessa. "The Truck Stop Killer." *GQ*, 2012. Retrieved from http://www.gq.com/story/truck-stop-killer-gq-november-2012.

WAPT-News. "Jury Reaches Verdict in Kidnapping, Rape Trial." 2012. Retrieved from http://www.wapt.com/article/jury-reaches-verdict-in-kidnapping-rape-trial/2077448.

Wexler, Stuart. "Mississippi Burning Killing: Religious Terrorism?" *Clarion Ledger*, 2014. Retrieved from http://www.clarionledger.com/story/journeytojustice/2014/07/09/sam-bowers-mississippi-burning-christian-identity/12394409.

ABOUT THE AUTHOR

Kristina Stancil has a master's in English from Tiffin University. Originally from Louisiana, she now lives in the North Mississippi area. Stancil is a regular contributor to *Serial Killer* magazine and *Halloween Haunts*. She has previously contributed to the *Houma Courier* and was interviewed by the Horror Writers Association as the August 2013 Fresh Blood Author of the Month. She is a member of the American Crime Writers League and was recently featured in its new member spotlight. She is currently attending Loyola University New Orleans' graduate program in criminology.

Visit us at
www.historypress.com